環保創藝

化廢為寶

CREATIVITY × TRASH

ART

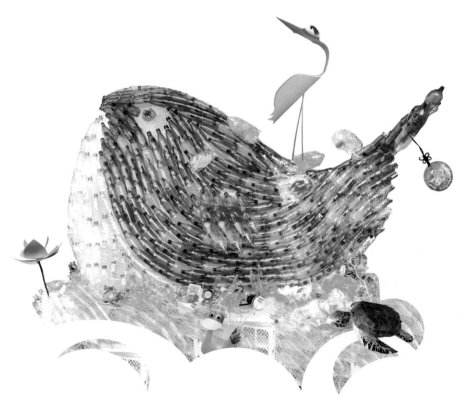

目錄

Content

福慧雙修 永續循環

◎葉欣誠

二〇二〇年是特別的一年！五十年前的一九七〇年，美國西雅圖一群大學生推倒了一輛象徵汙染的汽車，開啟了地球日（Earth Day）的故事與論述。三十年前的一九九〇年，慈濟體系以民間團體的角色，啟動了環境保護志業。

工業革命之後，西方世界的工商發展引領了全球的變化，到了上個世紀的後半段，人們已經歷了太多讓人不安的環境破壞與資源耗竭，紛紛透過倡議、政策、法規、教育等各種不同的手段，希望扭轉情勢。一九九〇年代開始，聯合國以「永續發展（sustainable development）」為指導原則，在全球推動與時俱進的政策與工具。雖然我們都很清楚，在二十一世紀的今天，全球環境問題仍然嚴重，氣候變遷已經被定位為「氣候緊急（climate emergency）」，然而我們更需要以決心和智慧，因應益發嚴峻的挑戰。

這「決心」與「智慧」，就是人們能夠維繫「永續發展」此一動能的關鍵。人類在長遠的發展歷程中，總能克服各類外來與內在的挑戰，讓生命得以延續，核心驅動力就是我們對於生命的珍視與人道的關懷。因為不忍看到生命的消逝，希望人們可以有更好的生活環境，大智慧者運用各種方便巧妙的方法，將重要的概念傳達給更多的人，希望從心念改變個人的行為，進而產生集體行為改變。

用現代語言來說，這「決心」就是人類文明持續進化與提升的力量。「智慧」則是人類希望找到面對問題解決方案的能力，無論是科技、法規、制度或相應的策略與作為，在人道關懷的價值觀與態度驅

The Everlasting Cycle of Merit and Wisdom

◎Shin-Cheng Yeh

2020 is a special year! Fifty years ago, in 1970, a group of college students in Seattle in the US overturned a car, which symbolized pollution, initiating the story and discourse of Earth Day. Thirty years ago, in 1990, Tzu-Chi, as a civil and religious NPO, launched its environmental protection missions. Since the industrial revolution took place, the industrial and commercial development of the western society has led the global change, which resulted in the severe environmental degradations and resources depletion experienced by the human being in the second half of the 20th century. Thus, initiatives, policies, regulations, education, and other diversified approaches have been proposed and implemented, aiming at reversing the situation. Since the 1990s, the UN promoted policy-based tools guided by the principle of "sustainable development". Although we all know that global environmental problems are still in a strict situation that climate change has been redefined as "climate emergency", we need to combat the challenges with determination and wisdom.

The determination and wisdom are precisely the keys for the human being to maintain the momentum of heading for sustainable development. In the long-term developing history, people can always overcome all kinds of external and internal impacts, sustaining human lives. The core driving force is then our cherish toward lives and humanity concern. For offering better living and experiences for the general people, the great wise men took various convenient and delicate approaches to broadcast key concepts to more people, intending to generate collective behavioural change through changing their minds. The determination is thus the power keeping the civilization revolving and upgrading, whereas wisdom is the competency for finding the solutions to the problems. Driven by the values

動下，知識與技能的持續提升，更前瞻而有系統地預防與解決問題，並結合社會的商業模式，讓「善意」、「發心」的理想得以實踐。

過去三十年以來，慈濟在環境保護與永續發展方面的決心與智慧，展現在廣大志工的具體實踐、在社會與學校中的深入教育，和對全球實際的影響中。

這次出版的《環保創藝 化廢為寶》專書，就是這福與慧的綜合表現。在資源管理的系統中，不產生或減少廢棄物當然是最高指導原則，然而務實面對真實的資源消費，能夠妥善地回收與再利用，讓物盡其用，看似簡單，事實上是構成循環經濟，促成永續發展的關鍵作為。慈濟的志工發揮巧思，把資源回收再利用的過程，賦予更新一層的意義。愛地球、惜資源的心，透過規畫與設計，以包括高度藝術意義的方式呈現，理性與感性兼具，展現了慈濟志工的用心與專業。

慈濟這幾年，事實上更入世的關懷作為發展相當具體，譬如大愛感恩科技運用回收寶特瓶為原料，創造了真實的循環經濟案例，不僅建構了資源循環系統，更將產品應用在救災等人道用途上。以促進永續發展的觀點來看，這樣結合經濟、社會、環境完整面向，善用科技，且訴諸生命價值的實務，的確難得。

人類雖然面臨重大挑戰，這本書和其代表的精神，讓大家在微笑中看到希望。

（本文作者為國立臺灣師範大學環境教育研究所教授）

and attitudes of humanism, technologies, laws and regulations, institutions, or corresponding strategies and applications were promoted steadily in terms of knowledge and techniques, resulting in forward-looking and systemic tools for problem prevention and mitigation. Moreover, social issues and business models were incorporated to make the goodwill and motivation finally come true. In the last three decades, Tzu-Chi has demonstrated its determination and wisdom in environmental protection and sustainable development via the practices of volunteers, deep-rooted education at schools and in the society, as well as those real impacts to the global community.

This book entitled "Creativity x Trash = Art" represents the practice of merit and wisdom. In the systems of resource management, zero waste/ waste reduction is the priority in an idealized situation. However, in reality, recycling and reusing materials, although look easy, are the keys for constructing circular economy and further enhancing sustainable development. The volunteers of Tzu-Chi, with ingenious inspiration, added extended meanings to the processes of recycling and reuse. The minds of cherishing the Earth and conserving resources were demonstrated with artistic arrangements, showing both rationality and sensibility that were embedded in their diligence and professionality.

With humanity concern in mind, Tzu-Chi has implemented some more engaged actions. For example, DA.AI Technology created real examples of the circular economy through reusing PET bottles as the materials. The treasured practices incorporated technology and life value while taking into account the triple bottom lines of economy, society, and environment. Although we are facing significant challenges, the book and its spirit let us see hopes with smiles.

（Mr. Shin-Cheng Yeh, Professor, Graduate Institute of Environmental Education, National Taiwan Normal University）

善盡資源永續

◎黃謙智

隨著文明的發展，大量生產讓我們的資源取得成本更低也變得方便，每一位地球公民如何看待資源的運用，對環境和未來都產生極大的效應。

我們既是消費者，也是未來市場的投資者，如何從源頭改變傳統線性的製造思維，讓資源能夠不斷循環，每一個自發性的善念，都能為世界帶來影響力。

「資源再利用」從來就不是一個當代的觀念，也不是當資源不均時才開始思考的議題，在過往的文明中，能夠繁榮發展的大城市，都看得見資源再利用的智慧。

當資源不再是秤斤論兩，當消費者更加重視環境議題，回收的下一步便是規畫好資源的退場機制。

「小智研發」自成立以來，致力於永續材料的創新應用，不只是回收再利用，更是去思考如何將廢棄物「升級再造」，將回收的廢棄資源加上些許的創意巧思，研發與設計出革命性的回收複合材料，生產過程可以避免開發新的資源，產品於使用後可以回收再利用，減少資源浪費，降低碳足跡。

「減量化、再利用、再循環」為的是減少消費行為過程中所產生的浪費。每項準則有助於達到節能減碳與環境保護目標。

環保不是口號，社會要能革新不只需要萌芽的善念，更需要身體力行實踐。

Sustain Resources

◎Arthur Huang

With the development of our civilization, mass production allows us to obtain resources with a cheaper and more effective way. It is very impactful to our environment and future on how each one of us use these resources.

Since we are both consumers and investors for the future market. How to adjust our mentality for mass production in order to sustain the resources can be influenced by every loving-caring thoughts, that can also make a difference in the world.

"Reuse of resources" has never been a contemporary concept, nor is it a topic that to be considered only when resources are uneven distributed. In the past, we can easily discover people's wisdom to reuse the resources in the big cities that are well developed.

The plan of sustainability is the next topic to be discussed when resources are no longer just a price tag and people are more aware of environmental issues.

Miniwiz has been committed to the innovative application of sustainable materials ever since it was founded 15 years ago. It is not only about how to recycle and reuse, but also how to "upcycle" waste by adding a little creativity. Designing a revolutionary re-engineered material, avoiding the use of virgin material during production process are different ways to insure that the product can be recycled and reused without creating more waste and at the same time reducing carbon footprint.

To "reduce, reuse and recycle" is to decrease the amount of waste

慈濟早在三十年前即推動環保意識落實日常生活中，至今回收已經是臺灣人民人人心中都普及的觀念。

《環保創藝 化廢為寶》專書內更是許多人的生活智慧觀察，將許多人眼中的廢棄物，透過巧思升級再造成令人驚豔的作品，運用生活中的廢棄物取代新材料，賦予廢棄物新的價值，無論實用度還是美觀都是令人激賞的創意呈現。

地球資源本自具足，一個創意便能激生萬法。

當全體公民能自覺行動，讓我們所有的產出，都能有不斷再被利用的機會。

這一切的善才能真正地循環。

（本文作者為小智研發共同創辦人暨執行長）

resulting from the process of our consumption. Each action will help us achieve energy saving, carbon reduction, and environmental protection goals.

Environmental protection is not just a slogan. Action speaks louder than words.

For 30 years, Tzu Chi Foundation has been working with different communities to promote environmental protection awareness in our daily lives. So far, recycling has become a common concept among people in Taiwan.

The book "Creativity x Trash = Art" shares the wisdom and observation of many people. They took the waste for other people and turn them into amazing works through their ingenuity. They only used post-consumer waste without using any virgin materials. By doing this, they gave waste a new meaning. Their works, in terms of practicality and beauty, are inspiring and creative.

The Earth's resources are self-sufficient, and a single innovative idea can stimulate many good things.

When all global citizens are conscious with their actions, everything that's produced will have opportunities to be reused.

The cycle of goodness will truly continue, if people have all these good thoughts and do all these good deeds.

(Mr. Arthur Huang, Co-founder & CEO of Miniwiz)

推動財智雙循環

◎顏博文

一九九〇年八月二十三日，證嚴法師在臺中新民商工的一場「幸福人生」講座，因為聽眾熱情的掌聲干擾了演說，讓法師想起當天清晨途經一處夜市空地時，看到剛結束的夜市滿地垃圾的情景，於是當場呼籲聽眾「用鼓掌的雙手來做環保」，從此，開啟了慈濟人動手做環保的一頁。

至今三十年來，慈濟環保志工不曾停歇，每天穿梭鄰里巷弄、商家工廠回收資源，儘管許多人年紀很大了，不但假日不打烊，每逢家家團圓的農曆年前，甚至動員更多志工，回收分類每個家庭大掃除後巨量的可循環資源。

由臺灣出發，至二〇一九年底，全球慈濟環保志工超過十一萬人，在十九國家地區設立逾一萬個環保教育站、環保點。

由愛護地球的一念心開始，慈濟環保導入科技——回收、分類、造粒、抽紗、紡織、銷售等多道流程研發，形成一個環保紗的供應鏈，這也是目前全世界都很重視的「循環經濟（Circular Economy）」。

慈濟的環保志業已創造完整的經濟循環，將環保志工回收分類的塑料，透過環保科技再製成各種賑災和生活實用的再生產品，實踐所謂的「循環經濟」；而環保志工回收所得，再挹注大愛電視臺製播美善訊息、優質節目傳播全球，很多人因此被感動，也願意來做環保志工，形成慈濟人文的「精神循環」。兩個循環加起來，構成如數學「無限大∞」符號，這全球獨一無二的「慈濟環保一條龍」，生生不

Promote Fortune and Wisdom Cycle

©Po-Wen Yen

On 23rd August 1990, during a talk on "Living a blessed life" which was held at Shin-min Commercial And Industrial Vocational High School in Taichung City, when the speech was interrupted by an enthusiastic round of applause from the audience, Master Cheng Yen took the opportunity to address a public cleanliness concern which she recalled from the sighting of a heavily littered night market location during her morning walk. She made an appeal to the audience in attendance to use the same pair of applauding hands to carry out environmental protection works and it was from that very faithful day where Tzu Chi volunteers started their first page in the journey of environmental protection.

For the past 30 years, Tzu Chi's environmental protection volunteers have never ceased in their efforts for the environment as they would go on their daily rounds in the neighborhoods to carry out recycling collection works. Although most of them are advanced in age, they remain very active in helping out with the collections and would even turn up on holidays including Chinese New Year eve where most would be at home having reunion dinners with families, they would mobilise even more of their fellow volunteers to help out with the overwhelming amount of recyclables sprung from the spring cleanings of each households. Started in Taiwan and has since expanded to 19 countries, the number of environmental protection volunteers has surpassed the mark of 110,000, with close to 10,000 over environmental education centres and recycling points established.

Stemming from the thought of caring for our planet, Tzu Chi introduced technological integrations into its recycling works, from the process of collection, sorting, granulation, yarning, fabrication and marketing of the finished eco product which forms a supply chain that is sustainable, and into something the world is holding in high regards right now, which is the Circular Economy.

息，鼓勵更多人來響應、力行環保。

二〇二〇年，是慈濟推動環保三十周年，亦是「世界地球日」五十周年。在此值得重視與紀念的一年，慈濟「環保三十・全球行動」呼應推動系列活動，包括慈濟環保論壇、環保教育行動車特展、與《國家地理雜誌》合辦環保路跑、「蔬食無痕、環保無塑」倡議野餐日，並特別出版《環保創藝 化廢為寶》專書——翻開這本書，我們不免讚歎，慈濟環保志工化廢為寶的藝術與巧思，以及珍惜地球資源如寶藏的心意。

本書彙集環保志工從二〇一一年開始發想的回收藝術創作精華，這些創作，賦予回收資源全新的生命力與教育力。在全臺各地與海外的燈會活動、環保特展展出，這些藝術創作以慧點的設計和亮眼的造型，吸引社會大眾緩下腳步，透過慈濟志工的導覽說明，感受環保行動刻不容緩、環保生活隨處可以力行。

最令人感恩的是，每位創作者毫不藏私，透過本書提供詳實的製作步驟，協助有心者逐步完成作品，期待邀請更多有心人，觸發創意、珍惜資源，從日常生活中踏實行動。

二〇二〇年一月「世界經濟論壇」指出，影響全球經濟發展的前五大因素都和氣候變遷及其引起的天然災害相關，全球風險報告書更預測二〇二〇年為「不安定的世界（Global Risks 2020: An Unsettled World）」。加上今年年初開始新冠病毒狂襲全球，至今仍未停歇，重創各國經濟與人民生命安全，猶如一記驚世的警鐘，提醒人類的經濟活動與生活方式過度使用地球資源、破壞物種的生態平衡，因而造成大自然的反撲。

有鑑於此，我們認為力行環保、推動茹素刻不容緩，而且必須

Tzu Chi's environmental mission has managed to established a complete circular economy, right from the process of sorting the recyclables collected by the volunteers, to the integration of eco technology in the fabrication of disaster relief supplies and lifestyle products, living out the value of circular economy in its path. Funds that are generated from the recycling collection are channeled to sustain the operation of Da Ai TV station which propagates kindness and humanity in its programmes, touching the hearts of many whom would in turn become environmental protection volunteers, thus achieving the cycle of love from Tzu Chi's humanitarian spirit. With the two cycles coming together, a symbol of infinity ∞ is formed as it becomes a one-stop environmental protection process which is sustainable on its own where it encourages a never ending flow of people to support its cause through environmental actions.

2020 is the year which marks the 30th anniversary of Tzu Chi's Environmental Protection mission, which happens to coincide with Earth Day's 50th anniversary. In such a year of commemorative value, Tzu Chi launched its 30th anniversary event themed "Eco 30 Global Actions" with a series of activities like eco forum, environmental education exhibitions on the wheels, eco run in collaboration with National Geographic, zero waste picnic, and this specially published "Creativity x Trash =Art " book. Upon flipping the pages of this book, it is hard not to be left in awe by the creativity of these volunteers who turned trash into precious work of art, along with their commendable extend in treasuring of resources.

The content of this book was compiled from the documentation of the eco volunteers' creative craft works since 2011, which brings with it a new perspective on environmental education as well as giving new lease of life to the concept of recycling. During the local and overseas lantern festivals where the eye catching bright ideas of the eco volunteers that are on display would attract glances and attention of participants whom would be given a guided tour of the exhibits and would come to terms with the importance and urgency of environmental actions which can be practiced everywhere.

擴大參與層面及力度，才能緩和環境變遷帶來的衝擊。祈願大家一起來，身體力行並推動！

　　誠摯希望本書的出版，讓更多人對DIY化廢為寶另眼相待，並思考改變個人的生活習慣，一起做出對地球環境更好的消費選擇和生活方式。真心期待有更多積極改變的行動者加入——那可能就是正在閱讀的您。

　　　　　　　　　　　　（本文作者為慈濟慈善事業基金會執行長）

The most grateful part of which is the selflessness of each idea creator, sharing their creation process in details which helps to guide its readers through their own process of replicating these art works and hoping that through these interactions, it would inspire more people to be innovative in the treasuring of resources, as well as practicing them in their daily living.

In January 2020's World Economic Forum, it was pointed out that the top five factors affecting the development of global economy are all interrelated with climate change, as well as the causes of natural disasters. The Global Risk Report predicted an unsettled year for the world in 2020, which was evident from the start of the year looking at the Covid Pandemic's global impact which has threatened lives and economies all over the world, and has yet to show any signs of easing up till date. The current global situation serves as a stark reminder for everyone to reflect upon our over-consumerism and environmentally destructive ways, which has brought upon retaliating effects that are threatening our way of life.

In view of the mentioned, we believe that the practice of environmental protection and adopting of a plant-based diet has to be strongly advocated with urgency, which needs to be responded with a larger participation in order to mitigate the impacts from environmental change. Let us come together and encourage more people to join in the green change as we put into practice a new way of lifestyle that is sustainable to the environment.

Through the publication of this book, we hope to provide a new perspective on DIY upcycling to more people out there, as well as to reflect on our living habits while make responsible choices in our consumer options and lifestyle.

Sincerely looking forward to more environmentally aspiring individuals to join in the green movement, which might very well be you whom is reading this right now.

（Mr. Po-Wen Yen, CEO of Buddhist Tzu Chi Charity Foundation）

創藝無限

◎沈明霞

　　根據行政院環境保護署公布資料，二○一五年臺灣資源回收率高達百分之五十五，相較之下美國的回收率僅有百分之三十五。擁有兩千三百五十萬人口的臺灣在資源回收成果上，得以媲美國際典範奧地利、德國和南韓。

　　慈濟自一九九○年八月在臺中南屯區成立第一個環保點，三十年力行這個環保大願，為減少全球災難、降低溫室效應，做出了貢獻。回收工作以外，慈濟並推動環境保護的概念與教育推廣計畫，「清淨在源頭」，盼從人人手中守護好每一個環節。

　　截至二○一九年，慈濟環保志業在全球十九個國家地區開花結果，擁有十一萬兩千零一十六位受證環保志工，包含臺灣地區環保志工八萬八千九百六十四人。

　　小從三歲幼兒、長至百歲人瑞，不分男女老幼，同一信念與心願投入環保行列，用寸寸愛、一步步鋪出一條環保的康莊大道，帶動全球守護大地。

　　慈濟推動環保所成就的「碳效益」，自一九九二年至二○一九年累計，合計兩百八十二萬四千兩百四十八噸，相當於七千兩百六十一座大安森林公園二氧化碳年吸附量，也等同於兩億三千五百萬棵樹一年的固碳量。力行資源回收再利用、延續物命的理念，帶動知福、惜福、再造福的善與愛的影響力，用行動顛覆當年《華爾街日報》報導的垃圾之島。

Infinite Art Creativity

◎Ming-Hsia Shen

According to the statistics published by the Environmental Protection Administration Executive Yuan, in year 2015, the recycling rate in Taiwan was 55% while America only managed to achieve a rate of 35% in comparison. With a population of 23.5 million, the recycling feat as achieved by Taiwan is enough to put them among the ranks of green countries like Austria, Germany and South Korea whom are regarded as international role models in environmental conservation.

Ever since the establishment of the first recycling point in Nantun Dist., Taichung City in August 1990, Tzu Chi have been devoting their cause towards the goal and aspiration of environmental protection, contributing to the mitigation of global warming as well as disasters across the world. Apart from recycling collection, Tzu Chi has been advocating on environmental awareness and education, focusing on sustainability at source in hopes of inspiring everyone to fulfil their part in all aspects of environmental conservation.

Tzu Chi's environmental protection mission has spanned across 19 countries, with 112,016 certified volunteers worldwide, of which 88,964 are from Taiwan. These volunteers varies from different age groups and genders, with the youngest from 3 years old to the eldest whom is a 100 years of age, all coming together with one belief, one aspiration, for one cause, that is to pave the way towards a global environmental movement for the conservation of our planet.

From the statistics that were tabulated on the impact of Tzu Chi's environmental efforts between 1992 to 2019, there was a total of 2,824,248 tons of carbon footprints reduced. This is equivalent to the

此外，在塑膠危機中，建立回收創造轉機，回收七十支六百毫升的寶特瓶，即可製成一條環保毛毯。累計至二〇一九年，慈濟已輸出逾一百一十七萬條毛毯到全球各地賑災，約計八千一百九十萬支寶特瓶製成。

當構思出版《環保創藝 化廢為寶》這本書的大架構，每一則作品的發想，環保志工從彎腰做分類中激發創作動機，或因不捨珍貴的水資源被浪費、或因證嚴法師常提到「來不及」，這句話就像一聲響鐘，志工們捫心自問能再做些什麼？該如何把握生命良能？

靜心思量觀察周圍物品的特性與構造，體認到天地萬物都有特質和無限可能，志工們發揮生活巧思，打破一切框架後再製，並將作品擺放在適當的位置，不讓資源隨手丟棄成為垃圾。

有心的創作被保留下來，不僅延長物命使用價值，減緩地球資源被浪費，更有美麗又富創意的作品可供欣賞與學習，《環保創藝 化廢為寶》創作專書於焉產生。

不忍地球受毀傷的環保志工，有如巧手魔術師，一修一焊間化腐朽為神奇的火花，幻化作品如雨後春筍不斷湧出。

二〇一九年參與浴佛節浴佛臺「保護海洋尊重生命」的「水立方」，創作構思運用視覺布展，讓與會大眾體認「惜水如金」的重要。高約三米六的「水立方」，由一千支回收寶特瓶製成，呈現人類可使用的地表水，約一千支的其中一支，僅占地球全部水量的千分之一，倡議「惜水如金」水資源的重要。

分布浴佛臺周邊的海龜與鯨豚製作，事關環保教育。新聞報導中海龜誤食塑膠袋的畫面時有所聞，感於減塑行動人人有責，因此透過作品呈現，引發人人有感而化為行動，在生活中落實環保減塑。製作

carbon adsorption by 7,261 Daan Forest Park or a year's worth of carbon sequestration from 235 million trees.

Apart from that, amidst the environmental threat from plastic waste, Tzu Chi created a breakthrough by recycling 70 pieces of 600ml PET bottles into an eco-friendly blanket. Till 2019, there were already 8.19million of such bottles being recycled into 1.17million pieces of blankets that were distributed as disaster relief supplies worldwide.

In the conceptualisation of this book"Creativity x Trash = Art", a lot were structured around the process of the volunteers' idea creation, which revolves around the cherishing of resources, which is also inspired by Master Cheng Yan's frequent reminder of our depleting time.

Realising the unique characteristics and infinite possibilities of resources around us, the volunteers broke all boundaries to develop novel craft ideas which can be integrated into our daily living thus preventing precious resources from being unmindfully discarded. These green creations were crafted to have long retention values in them, promoting sustainable use of resources, which can in turn slow down the rate of damage to our planet, along with visually pleasing aesthetics which has learning and decorative purposes, thus leading to the write up of this book.

Out of compassion towards our ailing planet, the environmental protection volunteers put on their thinking caps and were magician-like, as each touch of modification sparkled into sprouts of creations.

In 2019's Tzu Chi Buddha Day ceremony, there was a Water Cube exhibit on display in the section themed "Protecting and Respecting the lives of the Ocean". The conceptualisation of the Water Cube's design was to help people realise the importance and preciousness of water through the utilisation of this visual artwork. The 3.6-meter-high Water Cube was created from 1000 pieces of recycled PET bottles. It is to illustrate that the potable water on earth surface which are available to mankind is only in

材料來自回收紙箱，紙類回收再利用同樣是環保行動之一。

二○二○年二月四日，「臺中慈濟有『藝』思！盞盞環保燈照亮臺灣燈會」活動中，慈濟臺中分會應臺中市政府之邀，在后里森林園區展出環保花燈。以寶特瓶拼成鯨魚造型的大型花燈，鼓勵人人減塑，不要造成海洋生態的浩劫，作品應用了十種不同顏色形狀、七百多支寶特瓶和上百個方型回收塑膠籃。

每年，慈濟人辦活動和會眾結緣，總會準備一些伴手禮，「水晶蘋果」取蘋果的諧音「祝福平安」，會眾收到無不歡喜。這也是從資源分類中發現，底部有內凹的回收寶特瓶，裁取適當大小，兩個扣在一起就變成一個收納盒，可放入祝福吊飾、靜思語卡片、糖果或其他小型結緣品。盒子鑽個洞，插上枝桿和兩片葉子，就是一個透光的水晶蘋果。

世間萬物蘊藏奇妙無盡藏，創意沒有標準，只要能應用均是寶。

慈濟宗教處環保推展組同仁，感動於環保志工用心創作的生活藝術品項，兼具環境保護也美化生活，於是從二○一一年開始收納作品照片，含括發想、製作步驟及簡報，期間歷經資料庫系統轉換仍完整保留史料。

二○一九年六月起，著手規畫來年二○二○年的「慈濟環保三十周年回顧與展望」，在感恩環保志工的系列活動中，融入這項創意發想作品的出版，同步呼應證嚴法師在二○一九年三月與行政同仁座談會中，所諄示：「要多鼓勵環保布展中創意發想的創意人……」

這本書的出版，最要感恩的是創意發想的創作者，無私大愛分享創意專利於環保教育並應用在日常生活，實實在在落實環保「簡約好生活」。

the ratio of 1:1000.

Among the craft exhibits that were featured in the Buddha Day Ceremony, there were craft models of sea turtle and whale made from recycled materials on display to generate awareness on marine pollutions. These days frequent news reports about sea turtles mistakenly consuming plastic bags as food can be heard of. As such, through these eco art crafts, the call for environmental responsibilities and actions to reduce plastic wastes are advocated to the public, encouraging the integration of environmental friendly actions into our daily living.

During the eco lantern festival that was held by Tzu Chi Taichung branch on the 4th of February 2020, they receive an invitation by Taichung City Government to exhibit eco lanterns in Houli Forest Park. Massive whale model lantern that were made from PET bottles were on display to encourage one and all to cut down on plastic wastes, so as to avoid catastrophic repercussions to the marine ecosystem. The enormous art piece compromises of 700 over recycled PET bottles that are of ten over different colours, along with over a hundred units of recycled plastic baskets.

Every year, volunteers would often prepare meaningful souvenirs as gift for participants in Tzu Chi's events. Of which are the "Crystal Apples", which are delightful gifts with well wishes for the recipient. Using two concave base plastic bottles which are cut into appropriate sizes to fit and form into a container and fitted with crafted stalk and leaves, a translucent "Crystal Apple" is materialised. The completed craft work can be used to store Jing Si Aphorism cards, small accessories, candies or even other mini souvenirs.

There are no absolute standards when it comes to creativity, if we can uncover the hidden potential of these resources and turn them into useful items, that is where it becomes a valuable item with its given second life.

Touched by the eco volunteers' creative efforts in their work of art,

再者，如果沒有陳蘇姍師姊串聯新加坡分會並喜獲劉瑞士執行長鼎力支持與祝福，新加坡志工團隊環保組、英文組的英譯護持，即無法順利發行中、英文合版，而敞開在寰宇流通的機會。

　　誠心期盼藉著本書的出版，可以讓大家更有信心，一起成為積極改變的環保行動家。

<div align="right">（本文作者為宗教處環保推展組助理專員）</div>

which not only beautifies our living environment but also contributes towards environmental protection, staff of Religious Culture and Humanitarian Aid Dept started to document their eco art craft efforts since 2011 and has managed to maintain all progress information intact despite going through a system migration in between those years.

Building on that, the planning for Tzu Chi Environmental Protection Mission 30th anniversary year in review & resolution started in June 2019. Among a series of appreciation activities for the environmental protection volunteers, this publication of creative arts was launched in conjunction with the anniversary, as well as to heed Master Cheng Yen's call at March 2019 staff meeting to give encouragement to those whom had shown creativity in the eco exhibits.

The publication of this book would not be possible without the selfless contributions from the idea creators' sharing of their creative works, which advocates on environmental awareness and the integration with our daily living, which stays true to the practice of adopting a simple and eco-friendly lifestyle. Also to mention, without sister Susan Tan's help to link up with Tzu Chi Singapore, as well as the translation assistance rendered by its team of environmental protection volunteers, along with the full support and blessings from CEO brother Low Swee Seh , it would not be possible to publish this book bilingually, which helps to open up more opportunities to connect with readers around the world. We sincerely hope that with the publication of this book, it will encourage more people to join the works of environmental protection and to actively encompass these eco values in their daily lives.

（Miss Ming-Hsia Shen, Assistant Specialist @ Religious Culture and Humanitarian Aid Dept. of Taiwan Buddhist Tzu Chi Foundation）

回收資源的化妝舞會

◎吟詩賦

舞會中首先登場的是「神奇的塑膠」。

維基百科對「塑膠」的定義，是指以高分子合成樹脂為主要成分，加入添加劑，如增塑劑、穩定劑、抗氧化劑、阻燃劑、潤滑劑、著色劑等，經加工成型的塑性（柔韌性）材料，或固化交聯形成的剛性材料。

塑膠最早來自於一八五○年代的英國，開發以來用途廣泛，分類方式有許多種，常用聚合物中骨架及側鏈的化學結構來分類，其中重要的有丙烯醯基塑膠、聚酯塑膠、矽氧樹脂、聚氨酯及含鹵素的塑膠。塑膠也可依合成時的反應來分類，例如縮合反應、聚合加成及交聯反應。

生活中常用的塑膠，大致分類如下——

Polypropylene（PP）聚丙烯：食品包裝、家用電器、汽車配件（如保險桿）。

Polystyrene（PS）聚苯乙烯：包裝材料、食品包裝、免洗杯、盤子、餐具、CD和DVD文件夾。

High impact polystyrene（HIPS）高衝擊聚苯乙烯：包裝材料、免洗杯。

Acrylonitrile butadiene styrene（ABS）ABS樹脂（丙烯腈-丁二烯-苯乙烯共聚物）：涵蓋電子設備（如顯示器、印表機、鍵盤）。

Polyethylene terephthalate（PET）聚對苯二甲酸乙二酯：飲料瓶、

The Costume Party of Recycling

©Yin Shi Fu

The first to be introduced at the party is "magical plastics."

Plastic is defined by Wikipedia as "the synthetic or semi-synthetic organic compounds composed of high molecular synthetic resins with additives such as plasticizer, stabilizer, anti-oxidant, flame retardant, lubricant and colorant, which are malleable and can be molded into solid objects."

The plastic material was patented in England in 1850s. Plastics are usually classified by the chemical structure of the polymer's backbone and side chains; some important groups in these classifications are the acrylics, polyesters, silicones, polyurethanes, and halogenated plastics. Plastics can also be classified by the chemical process used in their synthesis, such as condensation, poly-addition, and cross-linking.

Plastics used in daily life are classified below:

Polypropylene (PP) – food packaging , appliances, and car accessories such as bumper.

Polystyrene (PS) – food containers, food packaging, disposable cups, plates, cutlery, CD and DVD boxes.

High impact polystyrene (HIPS) – food packaging and disposable cups.

Acrylonitrile butadiene styrene (ABS) – electronic equipment such as computer monitors, printers and keyboards.

Polyethylene terephthalate (PET) – drinks bottles, plastic film and

薄膜、包裝。

Polyester（PES）聚酯：纖維、紡織品。

Polyamides（PA）聚醯胺：纖維生產、高爾夫球、漁線、汽車塗料等。

Polyvinyl chloride（PVC）聚氯乙烯：管件生產、浴簾、窗框和地板覆蓋物。

Polyurethanes（PU）聚氨酯：泡沫保溫、防火、滅火泡沫。

Polycarbonate（PC）聚碳酸酯：光碟、太陽眼鏡、防護罩、安全窗戶、指示 燈、鏡片。

Polyvinylidene chloride（PVDC）聚二氯乙烯：包裝（食品和藥品）。

Polyethylene（PE）聚乙烯：薄膜、包裝袋（一般常見塑膠袋）、填裝瓶（如沐浴乳、清潔劑）、管道。

Polycarbonate/Acrylonitrile Butadiene Styrene（PC/ABS）聚碳酸酯/ABS樹脂：融合了PC和ABS塑膠，用於汽車內飾和外觀配件、手機殼等。

此外，特殊用途的塑膠，還包括——

Polymethyl methacrylate（PMMA）聚甲基丙烯酸甲酯：隱形眼鏡、有機玻璃。

Polytetrafluoroethylene（PTFE）聚四氟乙烯：不沾鍋、管道密封帶、遊樂場水滑梯等。

Polyetheretherketone（PEEK）聚醚醚酮：醫療植入、航空航天模

microwavable packaging.

Polyester (PES) – fibers and textiles.

Polyamides (PA) or (nylons) – fibers, golf balls, fishing line and automotive coatings.

Polyvinyl chloride (PVC) – plumbing pipes, shower curtains, window frames and flooring.

Polyurethanes (PU) – cushioning foams and thermal insulation foams.

Polycarbonate (PC) – compact discs, sun glasses, riot shields, security windows, traffic lights and lenses.

Polyvinylidene chloride (PVDC) – packaging for food and medicine.

Polyethylene (PE) – plastic bags, plastic bottles and pipes.

Polycarbonate Acrylonitrile Butadiene Styrene (PC+ABS) – a blend of PC and ABS that creates a stronger plastic used in car interior and exterior parts, and mobile phone bodies.

Besides, other special plastics are as follows:

Polymethyl methacrylate (PMMA) (acrylic) – contact lenses and organic glass (perspex).

Polytetrafluoroethylene (PTFE), or Teflon – non-stick surfaces for frying pans, plumber's tape and water slides.

Polyetheretherketone (PEEK) – medical implant applications and aerospace moldings.

Polyetherimide (PEI) (Ultem) – a high temperature, chemically stable polymer that does not crystallize.

塑製品。

Polyetherimide（PEI）聚醚亞醯胺：耐高溫不結晶聚合物。

Phenolics（PF）酚醛樹脂：俗稱電木，用於電氣設備絕緣部件、紙層壓製品、熱絕緣泡沫材料。

Urea-formaldehyde（UF）尿素甲醛樹脂：餐具、裝飾品、電器零件、配電器具、電話筒、汽車零件、合板、接著劑、塗料、按鈕、容器、麻將牌、時針盤、筷子、衣鈕、瓶蓋等。

Melamine formaldehyde（MF）三聚氰胺-甲醛樹脂：玻璃、餐具、裝飾品、電器配件及外殼、配電盤、機械零件、汽車零件、麗光板、塗料、接著劑、容器、紙、布的樹脂加工。

Polylactic acid（PLA）聚乳酸：由玉米澱粉轉化，可微生物分解，市面上可見的如水洗雞蛋的透明外盒。

自面世以來，神奇的塑膠得到廣泛應用，但同時產生嚴重的環境問題。塑膠垃圾難以自然分解，導致固體廢物增加；流入海洋中，則導致海洋生物誤食、窒息、中毒等，影響海洋生態；焚化塑膠垃圾亦造成空氣汙染，部分塑膠，如聚氯乙烯（PVC）和聚碳酸酯（Polycarbonates）在某些條件下會釋出有害物質或內分泌干擾素，危害生物生育機能。

其他問題，包含塑膠生產商常在包裝上含糊地稱產品為樹脂，事實上是人造（合成）樹脂。一般人誤以為是天然樹脂而放心購買和使用。許多生產商也未清楚列出製造時加入的各式有害化學品。

有些塑膠不宜加熱或用來存放酸性飲品食品，有些塑膠不宜受陽光照射等，否則成分會不穩定而釋出。由於沒有即時危險，以致塑膠

Phenolics or phenol formaldehyde (PF), Bakelite – insulating parts in electrical fixtures, paper laminated products, thermally insulation foams.

Urea-formaldehyde (UF) – utensils, decorations, electrical parts, power distribution appliances, handset, car parts, plywood, adhesive, coatings, buttons, containers, Mahjong tiles, clock dials, chopsticks, clothing buttons and bottle caps.

Melamine formaldehyde (MF) – glass, utensils, decorations, electrical parts and covers, power distribution board, mechanical parts, car parts, Formica, coatings, adhesive, containers, resin finishing.

Polylactic acid (PLA) – a biodegradable thermoplastic made from fermented plant starch such as cornstarch. It can be used for plastic egg containers.

Plastics have caused serious environmental problems since they were widely used in the world. Because of being durable and resilient to natural degradation, they become waste. Plastics thrown into the oceans kill or poison many marine mammals that mistake them for food, which adversely affects marine ecosystems. Burning plastic waste containing PVC or polycarbonates produces hazardous substance endangering fertility of humans and other organisms.

Some plastic manufacturers often label RESIN instead of SYNTHETIC RESIN on the packages; therefore, it misleads the consumers to regard what they purchase as a safe product made from natural resin. Besides, many manufactures do not clearly list all harmful chemical additives used in their plastic products.

Some plastics should not be heated or used for the containers of acidic beverages, and some should not be exposed to sunlight or UV radiation, causing the emission of unstable elements. Because plastics products do

產品中各種有害物質已從不同途徑，尤其是飲食，進入和汙染人體。

其中，我們常使用的「寶特瓶」，大多為PET（聚對苯二甲酸乙二酯）材質，具有可回收再製的特性。根據行政院環保署資料，臺灣每年約使用十萬公噸的寶特瓶，如此大的用量若淪為垃圾甚至流入海洋，將造成重大汙染。

如何減少使用量、達到保護環境的作用？可以從攜帶環保水杯做起，人人有心地減用，一年下來累積的數量就非常可觀。

若真因為需要而使用了寶特瓶，也要注意做好回收。回收重點，第一是「簡單清洗」，避免細菌孳生及異味產生；第二「壓扁空瓶」，可減少回收載運過程的存放空間；第三是「栓回瓶蓋」，盡可能將可回收的資源全部回收。

寶特瓶硬度及韌性均佳的特性，使得回收之外，也能利用其性質製成各類藝術創作。本書前兩單元，即是以寶特瓶為主要材料，製出創意無限的飾品、生活小物，也能聚小為大，成為大型創意藝術。

除此之外，回收其他神奇的塑膠製品，改製成有趣、實用的創意藝術，將在本書第三單元中呈現。另外，金屬類、紙類、利樂包等材質也將上場，共襄這場盛大的、回收資源的「化妝舞會」。

只是，歸元無二路，回到事情的本質，「回收資源」不過是事後諸葛，最重要及最好的方式，就是減少使用，甚至拒絕使用，才是最佳解決之道。

not cause an immediate health hazard, their various harmful chemicals gradually enter and pollute human bodies through different ways, especially foods.

The plastic bottles mostly made from PET are often used in daily life; they are recyclable. According to Environmental Protection Administration, about 100,000 tons of plastic bottles are used in Taiwan every year; if these plastic trashes go into the oceans, they will seriously cause the ocean pollution.

How can we reduce plastic consumption for the environment protection? Each person can help reduce a considerable amount of plastic garbage every year if he or she starts with carrying reusable cups and makes every effort to avoid using plastic products.

However, if the plastic bottles are necessarily used, they should be recycled. Three steps are taken to recycle a plastic bottle: (1) cleaning it to keep the bottle germ-free and smelling fresh, (2) crushing it to reduce storage space, and (3) leaving the cap on it, if possible.

Because of the toughness of plastic bottles, they can be reused for making various kinds of handicrafts. In the first two units of this book introduces how to use plastic bottles to create small accessories as well as large-scale artworks.

In addition, how to make interesting, practical artworks with other recyclable plastic products will appear on the third unit of this book. What's more, materials like metal, paper and tetra-pak will also participate in the Costume Party of Recycling.

Nevertheless, recycling is like a Monday morning quarterback. The best solution to the issue of environmental pollution is to avoid using the materials mentioned above.

法在其中

創意發想

A way of Life - Creative Conceptual- isation

Water
Cube

水立方

創意發想／陳哲霖

水立方創作構思，是運用視覺布展，讓大家體認「惜水如金」的重要。

高約三米六的「水立方」，是由一千支回收寶特瓶製成，呈現人類可使用的地表水，約一千支的其中一支，僅占地球全部水量的千分之一。

根據科學數據，地球上百分之九十七點五的水是鹹水，剩下的百分之二點五才是人類能利用的淡水；在這比例極少的淡水中，只有百分之零點三的地表水和百分之二十九點七的地下水能為人類所用，其他百分之七十都被冰封在冰帽和極地裏。

如果看了這一連串的數據，還是無感水資源的稀有和珍貴，就透過水立方作品來了解吧！

假設將地球上所有的水裝進這一千支寶特瓶內，其中九百七十五支是鹹水，二十五支是淡水；淡水當中有十七支被冰封在冰帽和極地裏（白色瓶蓋）及七支地下水（綠色瓶蓋），最後人類方便取得的淡水只剩大約一支（藍色瓶蓋），相當於地球上所有水資源的千分之一。

證嚴法師經常呼籲大家要「惜水如金」，並且透過以下三個實際行動來珍惜水資源——「一筷省水」、「蔬食三好」、「隨身五寶」。

Water Cube

Idea Creator / JER LIN CHEN

The conceptualisation of the Water Cube's design is to help people realise the importance and preciousness of water through the utilisation of visual artwork.

The 3.6 meter high Water Cube is created from 1000 pieces of recycled PET bottles. It is to illustrate that the potable water on earth surface available to mankind is only in the ratio of 1:1000.

According to scientific research, 97.5 percent of the water on Earth is salty water and the remaining 2.5 percent is freshwater. Within this limited amount of freshwater, only 0.3 percent of surface water and 29.7 percent of ground water are potable, the remaining 70 percent is trapped in glaciers and ice caps.

If these data do not relate you to the scarcity and preciousness of water, let us try to understand it through the illustration of the Water Cube artwork.

Using 1000 PET bottles to symbolize all water resources on Earth, 975 bottles are salt water while 25 bottles contain freshwater. Of the 25 bottles of freshwater, 17 bottles with white bottle caps represent water locked in polar ice caps and 7 bottles with green bottle caps represent inaccessible underground water. Hence this leaves only one bottle with blue bottle cap representing potable water for mankind, which is equivalent to one-thousandth of all water resources on earth.

Master Cheng Yen often urges everyone to cherish water resources and this is achievable with these three actions: Save water with "1 chopstick" : Keep the tap water flow to the width of one chopstick. The three benefits of plant-based diet : Mitigate global warming, for betterment of body, health and respect for life. Always bring along "5 treasures" with you : Reusable food container, chopsticks, water bottle, handkerchief and a shopping bag

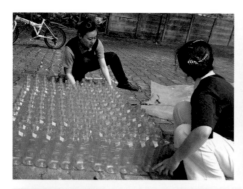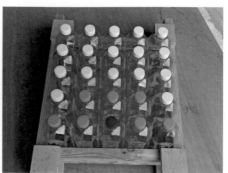
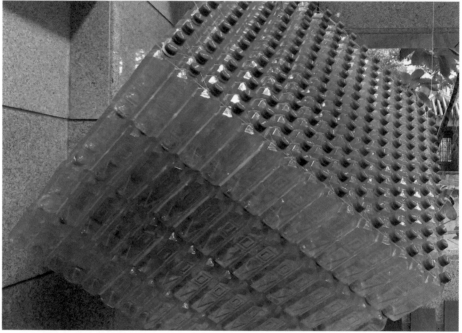

製作步驟

材料：一千支寶特瓶、木板、矽利康黏著劑

1　　收集一千支寶特瓶，清洗後晾乾。

2　　每二十五支寶特瓶，用矽利康黏成一小立方體，以木框固定，定型後取出；一千支寶特瓶共做出四十個小立方體。

3　　取三十六個小立方體組成一個大立方體。

Steps of Creation

Required materials: 1000 recycled PET bottles, wooden planks, silicone sealant

1　　Collect 1000 recycled PET bottles, wash and dry them.

2　　Glue every 25 bottles together with silicone to form a small cube. Use the wooden planks to frame up the 25 bottles for shape stabilisation. Once the cube shape is stabilised, remove the wooden boards. 40 small cubes will be created in total.

3　　Form 1 big cube combining 36 small cubes together.

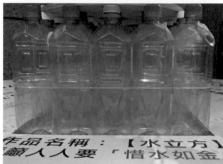

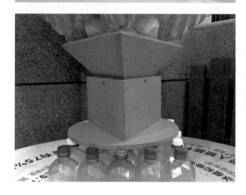

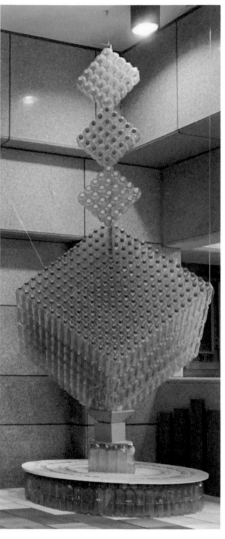

4　　　切割一個一百五十公分圓形木板當底座，貼上圖說。

5　　　放一個小立方體在圓形底座上。

6　　　用木板做出三角形木座，支撐上方的大立方體。

7　　　將三個小立方體吊掛在大立方體上方，完成作品。

4　　　Cut a 150cm round wooden plank to be used as the base.

5　　　Paste the explanatory labels on the base and put 1 small cube in the centre.

6　　　Use wooden planks to make a triangular pedestal to support the big cube.

7　　　Stack and hang 3 small cubes vertically above the big cube.

Water Cube artwork is completed.

4	
5	7
6	

鯨魚的眼淚

Tears of a Whale

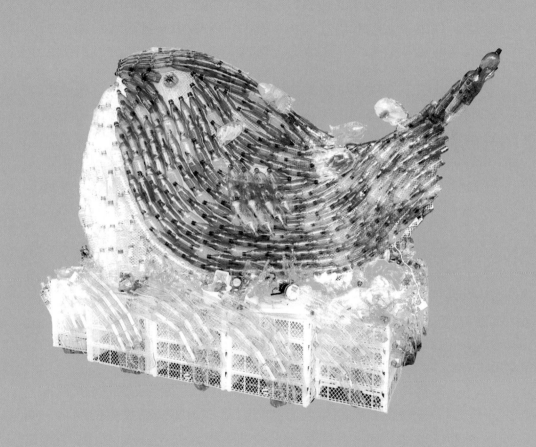

鯨魚的眼淚

創意發想／周秀琴

　　二〇一九年四月二十一日世界地球日，在臺北市大安森林公園舉辦的「蔬食無痕野餐日」活動，周秀琴帶領新泰環保教育團隊製作的動物模型參展其中，有石虎、蜜蜂、螢火蟲、黑熊、企鵝、鯨魚、海豚、北極熊和大象等。

　　牠們多為瀕臨滅絕的物種，是周秀琴受邀參展時，經過團隊討論而決定製作的項目。為了配合「環保無痕愛大地」的主題，他們在環保站搜尋可用素材，利用回收的塑膠籃做動物軀幹，外觀則以紙漿塑形。但其實沒有人做過紙漿，於是從網路上學習。周秀琴的心得是，對不熟悉的東西要有耐心，按部就班地做下去。

　　「無痕」意象的表達，是刻意裸露半邊的環保回收材料不做包裝，讓人一眼透視創作的元素，也是周秀琴為促進環保教育的巧思。

　　每一次創作，就迎來一次考驗。周秀琴表示要做這麼多的動物，卻僅有約十個人力，所以花了將近兩個月的時間才完成。

　　參展作品之一的鯨魚燈籠，使用了十種不同顏色和形狀、七百多支寶特瓶和上百個方型塑膠籃，因為材料收集很耗時，周秀琴一度擔心無法及時完成，所幸團隊成員相互成就，最後趕在時間內完成了「鯨魚的眼淚」大型作品。

Tears of a Whale

Idea Creator / Zhou Xiu-qin

On 21st April 2019, in conjunction with Earth Day 2019, Tzu Chi Foundation and Taipei City Daan Forest Park jointly organised a "Towards zero-waste, plant-based picnic" themed event, where Zhou Xiu-qin and the Environmental Education Team in her community participated with their animals-themed eco exhibits featuring leopard, bee, firefly, Taiwan black bear, penguin, whale, dolphin, polar bear and elephant etc.

These exhibits are mostly animals that are at the verge of extinction, an idea that was decided through a team discussion after Zhou Xiu-qin received the invitation to participate in the exhibition. In order to align with the zero-waste theme, the team searched for reusable materials at the recycling station. They used recycled plastic baskets to form the core structure of the animals and used paper pulp to shape the exterior. As no one in her team had any experiences with paper pulp, they had to turn to the internet for the knowledge of such creation. Through this experience, Zhou Xiu-qin had learnt to have patience and adapts step-by-step approach in managing unfamiliar tasks.

One of the distinct visual features of the exhibits was the intentional exposure of the reusable materials underneath, which is to express the concept of zero waste and to also advocate on environmental awareness, a thoughtful idea that was conceptualised by Zhou Xiu-qin. With each animal creation comes a new challenge. Zhou Xiu-qin had only ten volunteers to complete so many animal models, thus the team took almost two months to complete them.

The whale lantern, one of the exhibited artworks, was created from over 700 PET bottles of more than ten colours and shapes and hundreds of square plastic baskets. At one point of time, Zhou Xiu-qin was concerned on not being able to complete the project in time, as collection of the varied materials was time consuming. But fortunately, with great teamwork, they eventually managed to complete this massive scale creation, "The Whale Lantern", in time.

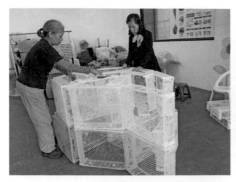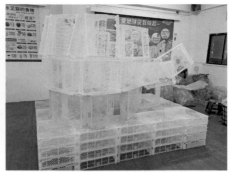
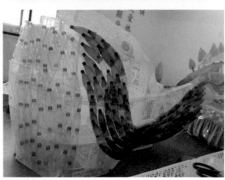

製作步驟

材料：塑膠籃、寶特瓶（綠色圓形、藍色圓形、透明方形、淺藍色方形）、電扇罩框、束帶

1~2　　以塑膠籃製作鯨魚架構，籃子之間以束線帶固定。

3　　　鯨魚外觀以圓形寶特瓶剪掉瓶底，套接串連。瓶身打洞以束帶固定在網片上，套接瓶子同時穿進LED小燈，從鯨魚尾部依弧度往前做。

4　　　鯨魚前腹用透明方形寶特瓶直立排列，背部和側面是藍、綠色圓形寶特瓶。

Steps of Creation

Required materials: Plastic baskets, Recycled PET bottles (green round, blue round, transparent square, light blue square shapes), electric fan casings, cable ties.

1~2　　Use plastic baskets to form the whale structure, and the baskets are connected with cable ties.

3　　　The exterior of the whale is made of bottomless round colour bottles, which are connected in series. The body of each bottle is punched with a hole and these bottles are fixed on the mesh with cable ties. Concurrently each bottle is inserted with a small LED lamp. These steps should be started from the tail of the whale following the body arc towards to the head.

4　　　Blue and green round bottles are used for the sides and back of the whale. While the front belly of the whale is made of transparent square bottles, arranged upright.

1	2
3	4

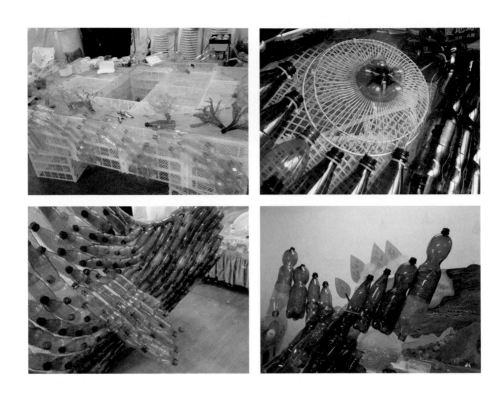

5 象徵海洋的平臺，以白色塑膠籃堆疊成回字型，淺藍色方形寶特瓶串接成海浪，以瞬間膠固定。海水裏有水草、魚類和人類製造丟棄的各種垃圾，藉境作為環保教育。

6 鯨魚的眼睛利用回收的電扇外蓋製成，眼珠是寶特瓶底座，襯以不同顏色。

7 魚鰭部分是在側邊預留位置，放置一塊硬板子，將魚鰭以瞬間膠黏在板子上。

8 魚尾部分則使用透明釣魚線將魚尾和魚身固定，保持懸空不下垂。

5 Platform that symbolise the ocean, is created with white plastic baskets stacked into a shape of the Chinese character回, light blue square bottles are connected in series to form waves, and they are fixed with instant glue.

In the sea water, there are water plants, fish and various kinds of garbage disposed by human beings. This polluted sea design is meant for environmental protection education.

6 The eyes of the whale are created with recycled electric fan exterior casing, and the eyeballs with the base of a different colour bottle.

7 At the side of the whale body, the fin is created with an extended hard board with colour round bottles glue onto it.

8 While at tail of the whale body, it is created with colour round bottles glue together and hang by a transparent fishing line to hold the tail firmly in air.

5	6
7	8

智慧大筆

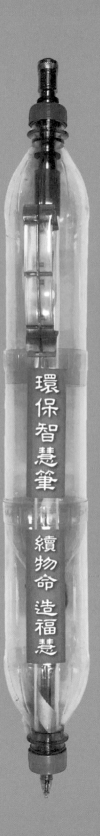

環保智慧筆
續物命 造福慧

Giant
Pen
of
Wisdom

智慧大筆

創意發想／陳建雄

　　環保智慧大筆不只是一支筆，還是說法的工具。

　　「回收的寶特瓶，把它當作廢棄物，它就是垃圾；把它當成資源，可以做成環保筆，可以變成幫助地球減少碳排量的一個工具。」二〇一九年十二月，靜思精舍清修士黃恩婷在西班牙馬德里參加第二十五屆聯合國氣候變遷大會時，因為要藉題說法、傳法，隨身帶著一支大型環保筆到處走。

　　為何會有這支大筆？話說當時大愛感恩科技公司利用回收寶特瓶製成環保智慧筆，成為證嚴法師贈送來賓的禮物之一。志工羅恒源提議特製一支大筆，方便法師開示時做介紹。

　　經營廚房衛浴設備的陳建雄，於是開始發想，到環保站找了兩支大寶特瓶及瓶蓋，加上大愛感恩科技公司的環保智慧筆，改造成一支大筆，於歲末祝福時呈給法師。之後，法師的每一場開示，都會拿出來向大眾介紹。

　　第一版的大筆稜角多且顏色不夠鮮豔，陳建雄思考如何製成一支可發光又真正能寫的筆？幾經試驗，最後挑選綠色圓形瓶身的寶特瓶，加上LED手電筒及紙張，瓶蓋打洞加墊片裝置大愛感恩科技的環保智慧筆，就這樣成為一支會發光又可以書寫的筆。

　　看似簡單的一支筆，製作起來可沒那麼容易；要收集合適的寶特瓶、瓶蓋及把手，再將寶特瓶剪裁、瓶蓋打洞，把手及各個零件的組裝，如果不是內心的禪定及智慧，細心地尋找合適的承接點，每一個步驟都可能前功盡棄。

　　二〇二〇年農曆大年初一，這支筆在靜思精舍展示時，志工

Giant Pen of Wisdom

Idea Creator / Chen Jian-Xiong

The Giant Pen of Wisdom is not just any ordinary pen, it is also a tool to promote environmental awareness.

"A recycled PET bottle will go to waste if it is thrown away as rubbish. Conversely, if the recycled PET bottle is treated as a resource, it can become an eco pen that will help reduce carbon emissions on earth." During December 2019, Jing Si Abode Practitioner Branda Hwang brought along the oversized pen to attend the 25th United Nation Climate Change Conference (also known as COP25) in Madrid, Spain. She utilises the giant eco pen throughout the journey to promote awareness on environmental education.

How did the innovation of this giant eco pen come about? Using recycled PET bottles, DA.AI Technology Co., Ltd. created eco pens as one of the gifts for Master Cheng Yen's guests. One of the Tzu Chi volunteers Peter Lo suggested making a giant eco pen to better facilitate Master Cheng Yen in her teaching of the eco pen during her speeches.

Owner of a kitchen and toilet amenities business - Chen Jian-Xiong, began exploring the creation of the Giant Eco Pen. Together with the DA.AI Technology Co., Ltd's eco pen, he integrated it onto two big recycled PET bottles and bottle cap salvaged from the recycling station into the Giant Eco Pen. This scaled up eco pen was presented to Master Cheng Yen during Tzu Chi's Year End Blessing Ceremony. Subsequently, in each enlightenment session, Master would use the Giant Eco Pen to explain to her audiences.

The first edition of the Giant Eco Pen had many rough edges and its colour was dull. Chen Jian-Xiong further explored on how to turn it into something that can both glow and write. After a few trials, he finally chose the green round recycled PET bottles, LED lights, some papers as the materials. He punched a hole in the bottle cap, added on a gasket to fit in the DA.AI Tech eco pen. This new design became the final Giant Eco Pen

鼓勵大家拿筆寫下新年大願，與會者莫不躍躍欲試。動腦仔細思考要寫什麼「字」？這時才深刻體會證嚴法師所說：「大筆寫大字。」而法師說的字，並非寫字的「字」，而是智慧的「智」，也是志願的「志」。

that can glow and write.

Though it may seem like a simple pen , but the process of creation is not easily made without a conscious and wise state of mind. The entire process involves collecting suitable PET bottles, bottle caps and handle, cutting the PET bottles, punching hole in the bottle caps, assembling the handle and other parts of the pen. With a mindful heart, one will then be able to find the right bearing point of each connection accurately in order to continue every other step smoothly. Without a well focus mind and wisdom of thoughts, it might not be possible to identify the subtle details in finding the critical and appropriate joining points, which might cause the process to end up in failure if neglected.

On the first day of Lunar Chinese New Year in 2020 at the Jing Si Abode, volunteers encouraged everyone to pen down New Year wishes with the Giant Eco Pen which many were interested to try. As they pondered what to write, Master Cheng Yen's teaching came to mind : "A Big Pen for writing an equivalent size Word(Zi) ." The Chinese character "Zi" that Master mentioned is not the "Zi" for "Word", but the "Zi" in "Wisdom" and "Aspiration". Hence, what Master Cheng Yen meant to preach was "A Big Pen is to write wise and aspiring words that are parallel in size".

Note : Word, Wisdom and Wish have a character that are of same pronunciation in Chinese.

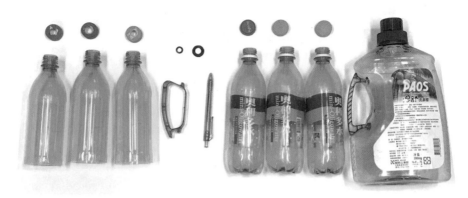

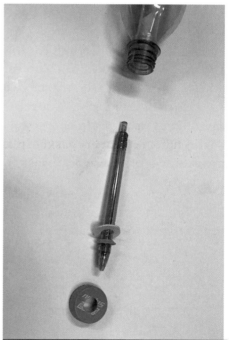

製作步驟

材料：綠色圓身寶特瓶三支、瓶蓋、塑膠罐把手、環保智慧筆一支、三段式LED手電筒、透明塑膠管、A4紙、墊片、塑膠片、「環保智慧筆」和「續物命造福慧」貼紙。

1　　拆解塑膠罐把手備用，寶特瓶裁剪如圖左，瓶蓋打洞。

2　　將把手鎖在其中一支寶特瓶上。

3　　將三段式LED手電筒裝入瓶中，瓶身貼上「環保智慧筆」、「續物命造福慧」貼紙，A4紙捲曲放入透明塑膠管中。

4　　加上墊片及塑膠片裝入打洞的瓶蓋中，即組裝完成。

Steps of Creation

Required materials: 3 pieces of green round recycled PET bottles, bottle caps, plastic handle, 1 piece of eco pen, 3-section LED light, transparent plastic tube, A4 paper, gasket, plastic film, [Eco Pen] and [Extending product life span is also accumulating merits] labels.

1　　Dismantle the handle from the plastic bottle. Cut the PET bottles as shown on the left side of the picture. Punch a hole on the bottle cap.

2　　Fix the dismantled handle onto one of the PET bottles.

3　　Insert the 3-section LED light into the bottles. Paste the labels [Eco Pen] and [Extending product life span is also accumulating merits] on the PET bottles. Curl the A4 paper and insert into the transparent plastic tube.

4　　With gasket and plastic film to the punched bottle cap hole. Connect up the 3 PET bottles and complete creation.

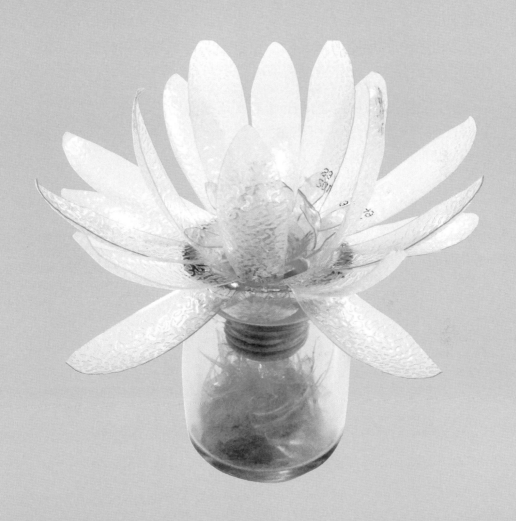

蓮花燈

創意發想／曾雅玲

　　「證嚴上人曾說，生活所需均開採大地資源而來，世間萬物均含物理。」曾雅玲思考，天底下所有物品，不僅開採自大地，還有相當繁複的生產歷程，因此留意觀察各類物品的特性，依其構造特性而創作，不經過燒烤造成二次汙染。

　　製作蓮花燈的寶特瓶，瓶身本具花瓣溝槽不需費心丈量，且有著透明婆娑的特性，不同顏色套疊起來相當漂亮。只要沿著紋路剪開即形成一朵蓮花。

Lotus Lamp

Idea Creator / Yalin Tseng

Master Cheng Yen once mentioned that everything we use in our daily lives is extracted from earth resources and all things have its own physics. On this, Yalin Tseng thought through and concluded that indeed all materials not only are extracted from earth resources, they also need to undergo complex production processes to reach it final form. Since then she started paying attention to different products characteristics and came up with creations based on their structural characteristics to avoid second stage production pollution.

Recycled PET bottles are used in the creation of the lotus lamps. The grooves on the bottles aid easy determination of flower petal sizes. Cutting along the grooves of the bottles will open the petals to form the flower shape. Stacking different colour bottles together creates a complete beautiful flower.

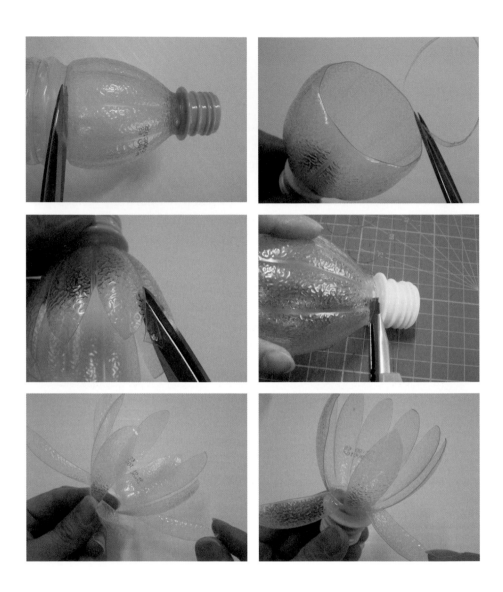

製作步驟

材料：瓶身有凹槽的綠色、透明寶特瓶

工具：裁切板、剪刀、鑽子、美工刀、保麗龍膠

1~2　　以鑽子穿刺小孔，剪刀繞一圈剪下，取下綠色寶特瓶上半截三分之一部分，修剪邊緣。

3　　　沿寶特瓶紋路剪開至離瓶口一公分，修剪成花瓣形狀。

4　　　透明寶特瓶去掉瓶口，其餘同前步驟剪出花瓣弧型。

5~6　　調整花瓣形狀，相隔一瓣往外扳開，兩者做法相同。

Steps of Creation

Required materials: Green and transparent recycled PET bottles with groove lines on its body

Required tools: Cutting board, scissor, bradawl, pen knife, super glue

1~2　　Then use a pair of scissors to cut out the top 1/3 of the bottle and trim the edge. Pierce a hole through the green bottle using bradawl at 1/3 point from the top of the bottle.

3　　　Cut along each groove until 1cm away from the bottle mouth and trim out the arc of each flower petal.

4　　　Remove the bottle mouth of the transparent bottle and repeat the above steps.

5~6　　Fold down on every alternate petal, do the same for both transparent and green.

1	2
3	4
5	6

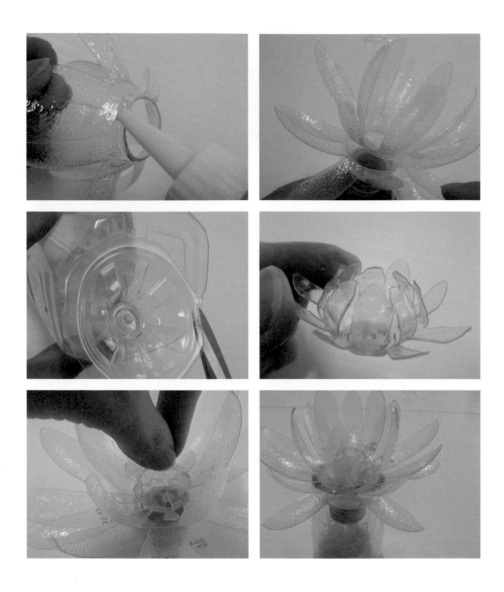

蓮花燈 Lotus Lamp

7 在透明花瓣底部塗抹保麗龍膠。

8 黏合至綠色花瓣上。

9 花心製作，取下綠色寶特瓶圓形底部。

10 沿紋路剪開至距離中心零點五公分，修剪出花瓣弧型，
相隔一片花瓣往內扳，調整形狀。

11 以保麗龍膠將花心固定在花朵中心。

12 將修剪下來的裁片放進玻璃瓶中作為底座，放上蓮花完
成作品。

7 Apply glue on the bottom of the transparent flower

8 Stick it onto the green flower.

9 To create the flower centre, cut out the circular base of the green
bottle.

10 Cut along each groove until 0.5cm away from the centre and trim
out the arc of each flower petal. Fold up on every alternate petal.

11 Glue and stick the flower centre onto the middle of the flower.

12 Put the leftover plastic shreds into a glass jar base, then place the
completed lotus flower on it.

7	8
9	10
11	12

水晶蘋果

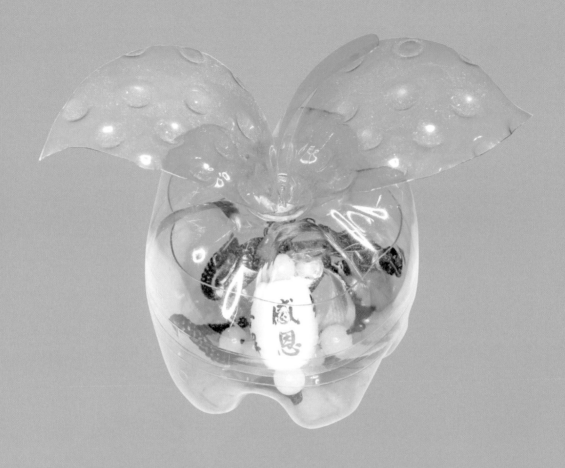

Crystal
Apple

水晶蘋果

創意發想／陳寶娟

　　慈濟人辦活動和會眾結緣，總會準備一些伴手禮，「水晶蘋果」取蘋果的諧音，祝福平安，會眾收到，無不歡喜。

　　挑選底部有內凹的回收寶特瓶，裁取適當大小，兩個蓋在一起就變成一個收納盒，可放入祝福吊飾、靜思語卡片、糖果或其他小型結緣品。盒子鑽個洞，插上枝桿和兩片葉子，就是一個透光的水晶蘋果。

　　世間萬物奇妙無盡藏，即是化無用為有用。

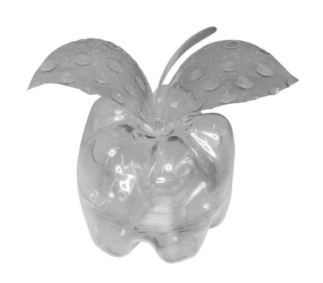

Crystal Apple

Idea Creator / Chen Bao-juan

During Tzu Chi events, volunteers would often prepare meaningful souvenirs to gift for the participants. Of which are the "Crystal Apples", which are well wishes for all to be safe as "apple" and "safety" are homophones in Chinese. Participants would rejoice when receiving these thoughtful souvenirs.

To create the "Crystal Apple", choose two plastic bottles that are concave (curved inwards) at the bottom and cut them into appropriate sizes where the 2 parts can fit together as a container. Create a small hole on the top of the apple and attach the stalk and leaves. The completed translucent "Crystal Apple" can be filled with Jing Si Aphorism cards, small accessories, candies or even other mini souvenirs as giveaways.

All resources in the world has its boundless potential to be converted into useful purposes.

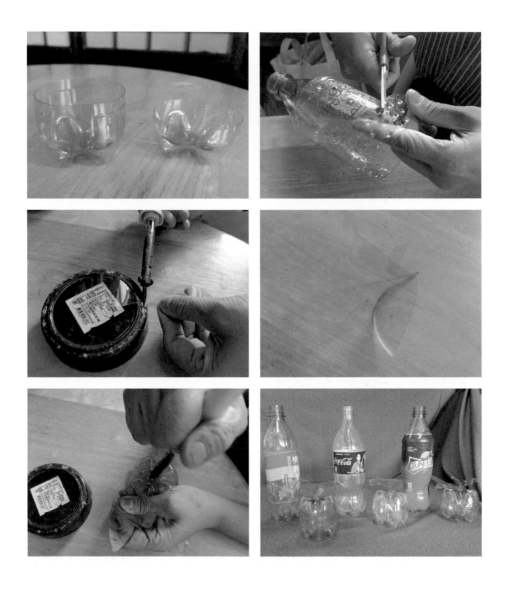

1	2
3	4
5	6

製作步驟

材料：寶特瓶（底部有腳形的）

工具：剪刀、烙鐵

1~2　　將寶特瓶底部裁切下來，修整銳利的邊緣，蘋果上蓋可以套在下部外面。利用剩餘寶特瓶剪出兩片相連的葉子。

3~4　　將枝桿的一端以烙鐵平行貼黏在兩片葉子中間（凸面方向），乘熱將葉片往枝桿方向對稱緊密壓折。

5　　　烙鐵加熱在上蓋中間鑽孔，乘熱將葉子插入孔內壓緊。

6　　　完成的環保水晶蘋果。

Steps of Creation

Required materials: 2 recycled PET bottles (concave at the bottom)

Required tools: Scissors, soldering iron

1~2　　Cut out the bottom part of the bottles and trim off the sharp edges. The bottom parts shall be in different sizes, as shown in the above picture. The taller piece forms the base of the apple while the shorter piece forms the top. Use the remaining parts of the bottles to cut out two interconnected leaves, as shown in the picture.

3~4　　Use the remaining parts of the bottles to cut out a stem for the apple. Using a soldering iron, stick one end of the stem to the middle of the two leaves and fold the leaves tightly towards the stem symmetrically while it is hot.

5　　　Using a soldering iron, make a hole in the middle of the cover of the apple, insert the leaves into the hole and press on firmly while it is hot.

6　　　The completed "Crystal Apple".

竹子盆栽

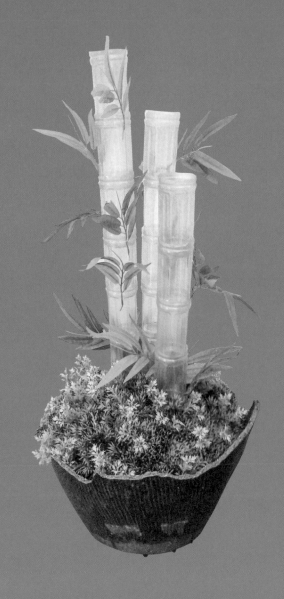

Bamboo
Plant

竹子盆栽

創意發想／曾雅玲

有形的物質，無不都是法，無不是道理。

此款帶紋路的寶特瓶，上段製成「蓮花」，底部製成「吊飾」，中段的材料，經過曾雅玲仔細觀察，它有著「竹節」的紋路。於是試著將瓶身中段接續起來，像是自帶卡榫，緊接不脫落，不偏不倚成就整體之美，如此「真空妙有」，竹德也！

Bamboo Plant

Idea Creator / Yalin Tseng

In Dharma saying "Any distinct substance can be created into a philosophical presentation."

This patterned bottle can be broken down to create few artworks. Its top portion can be used to create a lotus flower while its bottom can be made into ornaments. As for the middle section, after careful observation, Yalin Tseng realised it has patterns that resembles bamboo joints. Hence she connects the middle sections like inter-locking bamboo joints, materialising them into the beautiful form of a bamboo plant.

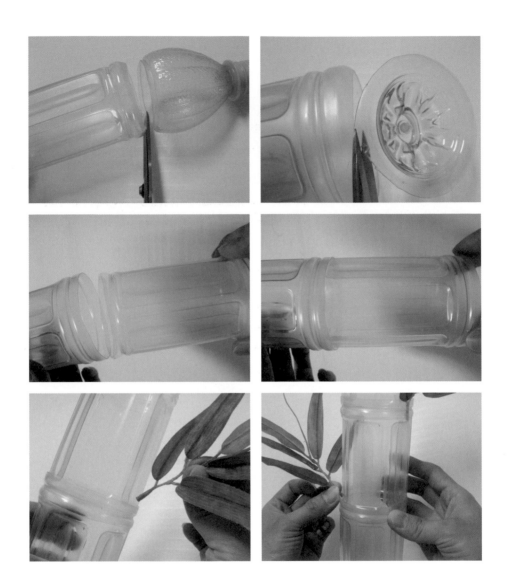

製作步驟

材料：帶紋路的綠色寶特瓶、竹葉

1~2　　剪下寶特中段，呈上下中空，修整邊緣。

3~4　　將數個瓶身上下互套，完成竹節。

5~6　　將竹葉加裝串接在竹節隙縫中。

Steps of Creation

Required materials: Green PET bottles with grooves, Bamboo Leaves

1~2　　Cut and separate the bottle section by top, middle and bottom. Trim the edges each section.

3~4　　Connect and inter-lock the middle sections to form the desired bamboo length.

5~6　　Insert bamboo leaves into the gaps at the inter-lock areas.

1	2
3	4
5	6

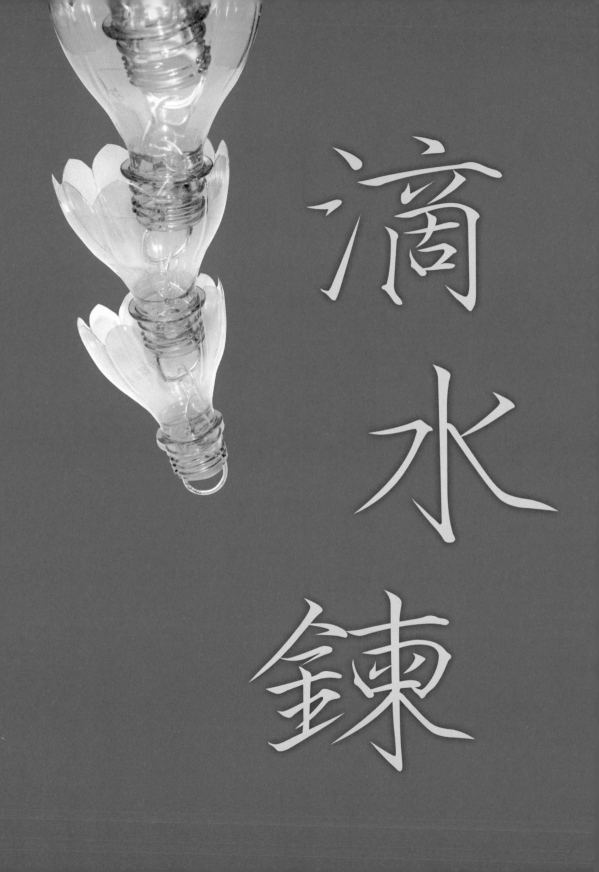

滴
水
錬

Rainwater
Drip
Chain

滴水鍊

創意發想／曾雅玲

　　二〇一二年，曾雅玲第一次返回靜思精舍過年，參與主堂《法華經》禮拜，尤其能見到證嚴法師並聆聽開示，內心無比寧靜，法喜充滿。

　　其間，一場午後大雨，她看見精舍多處屋簷漏雨，臨時棚布架上也積滿了水，於是發想出寶特瓶滴水練，可應用於承接屋簷雨水。

Rainwater Drip Chain

Idea Creator / Yalin Tseng

In 2012, Yalin Tseng went back to Jing Si Abode for Chinese New Year for the first time and participated in Lotus Sutra worship. The opportunity to meet Master Cheng Yen and listen to her teachings, filled Yalin Tseng with peace and joy.

During her stay, she witnessed a heavy afternoon downpour causing rainwater leaking from many eaves of the Jing Si Abode and canopies were full of rainwater. This sight inspired her to create the rainwater drip chain using recycled PET bottles which diverts rainwater flow.

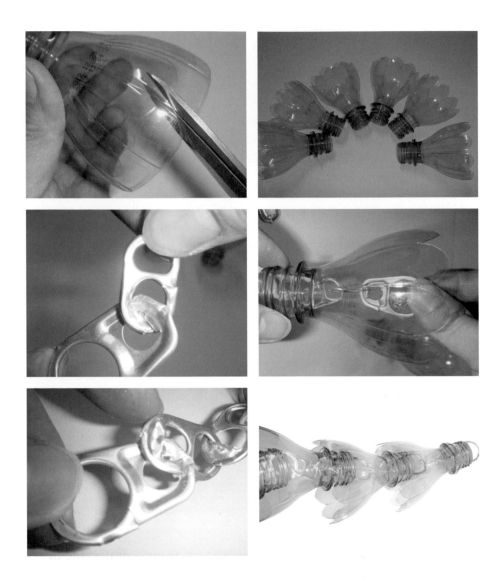

1	2
3	4
5	6

製作步驟

材料：寶特瓶、易開罐拉環

工具：剪刀、鑽子

1~2　　取下綠色寶特瓶上半截三分之一部分，修剪邊緣。沿寶特瓶紋路剪開至距離瓶口一公分，修剪成花瓣形狀。

3　　　鋁罐拉環去掉上端孔中心部分，在拉環側邊剪一出口，銜接下一個拉環呈長鍊狀。

4~5　　將鍊條穿過花朵中心，勾上大拉環作為擋環，調整花朵之間高度。

6　　　同樣步驟，連接至所需長度即完成。使用時花朵朝上承接，水即沿花朵引流而下。

Steps of Creation

Required materials: Recycled PET bottles, aluminum can pull rings

Required tools: Scissor, bradawl

1~2　　Then use a pair of scissors to cut out the top 1/3 of the bottle and trim the edge.

Cut along each groove until 1cm away from the bottle mouth and trim out the arc of each flower petal.

3　　　Remove the tab of the pull ring. Cut an opening at the side of the pull ring and connect to another pull ring to form a long chain.

4~5　　Place the chain through the middle of the flower and connect to a larger pull ring which serves as a stopper.

6　　　Repeat the same steps. Connect the flowers to the required length and adjust the distance between each flower. Place the flowers facing upwards so that rainwater will flow down through the flowers.

鼠來寶

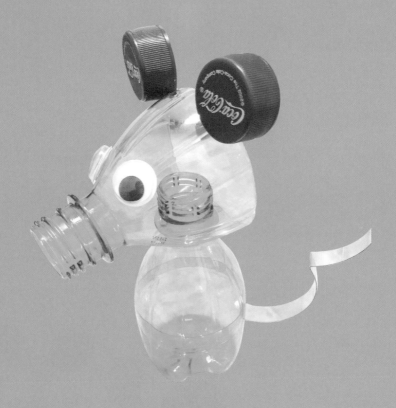

Fortune Mouse

「鼠」來寶

創意發想／曾雅玲

吉祥如意「鼠」於您！

幾個三角錐合起來就是一隻吉祥如意鼠。

環境好，健康好，尊重生命好，鼠年齋戒素食正是時機。

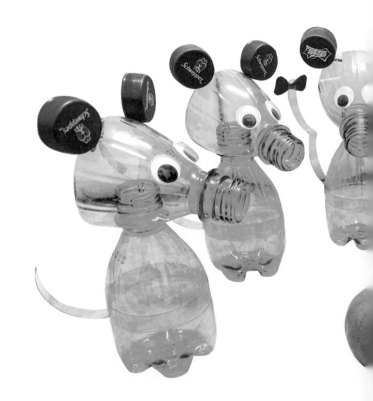

Fortune Mouse

Idea creator / Yalin Tseng

May the Auspicious Mouse be with you!

All it takes is to join a few triangular plastic cones together and you will have your very own auspicious mouse.

Coinciding with the year of the Mouse, it is just the right time to adopt vegetarianism for the good of the environment, for good health and to nurture compassion and respect for all life forms.

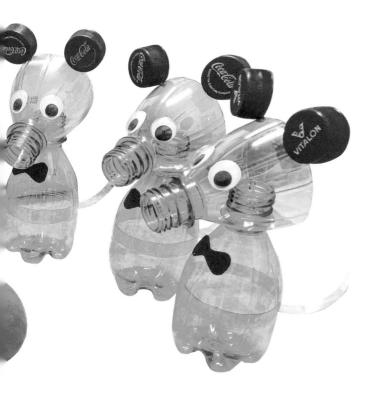

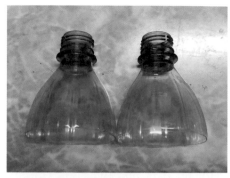 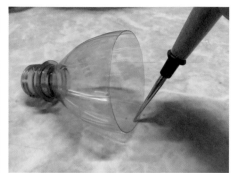

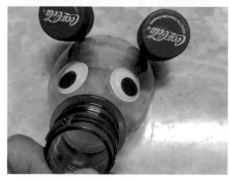

製作步驟

材料：寶特瓶、瓶蓋、小鋼圈、眼睛、雙面膠

工具：剪刀、錐子、尖嘴鉗

1　　　取下寶特瓶前端漏斗部分，兩個做一隻老鼠。

2~3　　漏斗寬邊和瓶蓋開口邊緣，往內零點五公分處鑽孔。

4　　　以小鋼圈連接兩者；同樣步驟兩次，做出老鼠耳朵。

5　　　以雙面膠貼上眼睛。

Steps of creation

Required materials: Recycled PET bottle, bottle cap, steel rings (small), handicraft eye, double sided tape

Required tools: Scissor, bradawl, noose piler

1　　　Cut out the cone shaped top of the bottle, two pieces are required for each mouse.

2~3　　Make a small hole on the cut-out bottle top, 0.5cm away from the edge of the broader opening. Make a hole on the bottle cap as well, nearing the edge from the inner side.

4　　　Use the steel ring to attach the bottle cap to the cone shaped bottle top. Repeat the step for the other bottle cap. This will form the two ears of the mouse.

5　　　Stick the handicraft eyes to the bottle with double sided tape.

1	2
3	4
5	

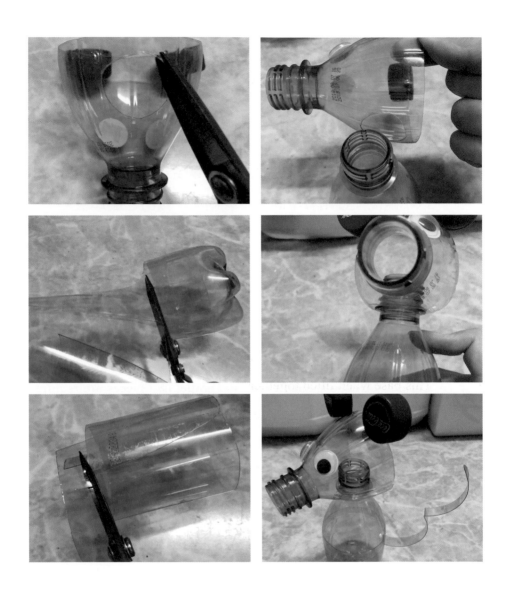

6　　在耳朵背面剪出圓孔。

7　　套入另一個漏斗頭。

8　　剪下寶特瓶底部，預留套疊部分一點五公分。

9　　套上老鼠上半身。

10　　以剩下瓶身剪出寬一公分的長尾巴。

11　　一端以雙面膠黏接身體，完成作品。

6　　Make a round hole at the opposite end from the ears of the mouse.

7　　The size of the hole should allow the second cone shaped bottle top to fit in nicely.

8　　Cut out the bottom of the bottle with a height that allows a 1.5cm overlap between the body of the mouse.

9　　This base when fitted together.

10　　Cut out a strip of 1cm width from the remaining of the bottle as the tail of the mouse.

11　　Stick one end of the strip with double sided tape onto the joint area. The art work is now completed.

6	7
8	9
10	11

吊飾及鑰匙圈 靜思語

Jing Si Charm and Keychain

靜思語吊飾及鑰匙圈

創意發想／曾雅玲

　　佛法提到，每樣物品均離不開地、水、火、風所聚合。

　　此款寶特瓶的特性，瓶身有方塊圖形，剪下兩片貼合在一起，中間加上「靜思語」，簡單的書籤吊飾就完成了。稍作變化，成為「有法」在身的鑰匙圈。

Jing Si Charm and Keychain

Idea Creator/ Yalin Tseng

In Buddhism, all things are interlinked with the universe, and are materialised from the combination of earth, water, fire and wind.

Similarly, this craft utilises the characteristics of square PET bottle and incorporating the elements of Jing Si Aphorisms to create a meaningful item which propagates wise advices. Just from a few simple pieces of plastics, it is turned into a key chain of philosophical values.

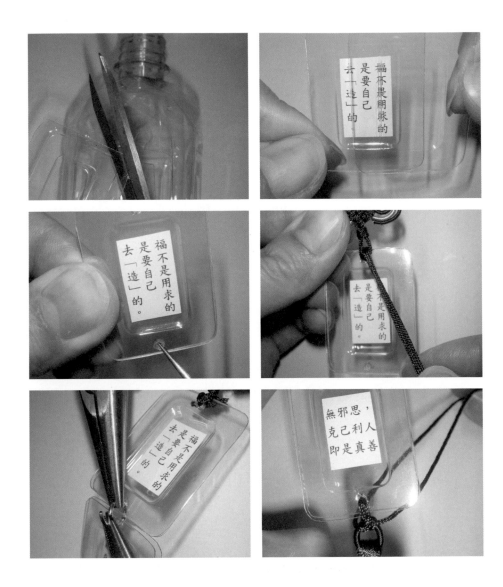

製作步驟

材料：方形寶特瓶、小鋼圈、中國結、靜思語紙片、雙面膠、鑰匙扣

工具：鑽子，尖嘴鉗

1~2　　剪下寶特瓶上半部方形框片兩個，修整邊緣，在兩片中以雙面膠貼上靜思語紙片。

3~4　　方框上下距外圍零點二五公分處各穿一孔，上端加上中國結。

5~6　　以小鋼圈串連數個靜思語方框，最末一個加上流蘇，完成吊飾。

Steps of Creation

Required materials: Recycled square PET bottles, small steel rings, Chinese knot set, Jing Si Aphorism notes, double-sided tape, keychain ring

Required tools: Bradawl, noose piler

1~2　　Cut out two rectangular frames from the top half of the bottle and trim the sharp edges. Paste a Jing Si Aphorism note on the inside of each frame using double-sided tape.

3~4　　Pierce a hole, about 0.25 cm from the edge, on the top and bottom of each frame. Tie a Chinese knot on the top hole.

5~6　　Attach a few completed Jing Si Aphorism frames together with small steel rings and tie the tassel at the bottom of the last frame to complete the Jing Si Charm.

1	2
3	4
5	6

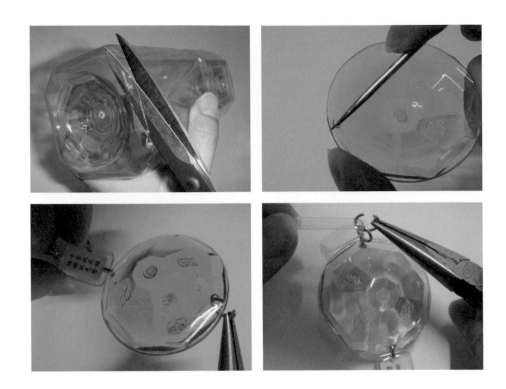

7　　　剪下寶特瓶底部圓形兩片。

8　　　在兩側距外圍零點二五公分處各穿一孔。

9　　　將兩個圓片相扣。

10　　　上端連接靜思語片和鑰匙扣，下端接上兩個橢圓裁片裝飾，作品完成。

7　　　Cut out the round base from two bottles.

8　　　Pierce a hole, about 0.25 cm from the edge, on the top and bottom of each round frame.

9　　　Fit the two round frames together.

10　　　Prepare a Jing Si Aphorism frame with a split key ring attached to it. Attach the Jing Si Aphorism frame to the top of the round frame with a mini circle jump ring. Finally, attach two pieces of oval-shaped plastics to the bottom of the round frame to complete the Jing Si Keychain.

7	8
9	10

特別的

寶貝

戀身變秀

A Transformation Show of Unique Gems

風鈴

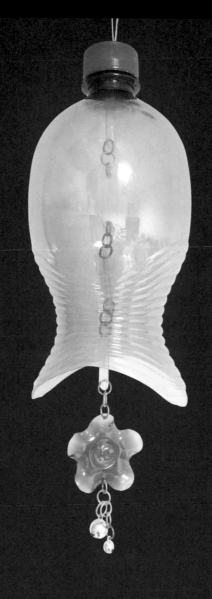

Wind Chime

風鈴

創意發想／曾雅玲

　　心，知識、智慧無形，發揮了知識、運用了智慧，叫做隨心。造物，即是將有形的物質，隨著無形的心念將它製作出來。將「無為法」與「有為」的物質會合起來，化成各種形相，就是隨心造物。

　　日常生活所用的東西，無不是隨人心造作的物質。名相之多，材質各異，各有其作用，和合而成各種相，隨心造物，莊嚴「心」的道場。

Wind Chime

Idea Creator / Yalin Tseng

The act of materialising an intangible thought into different forms of creations requires utilisation of the mind, wisdom and knowledge. This is called the creation of free-will.

The things that are used in daily living are all but creations of our free-will, where tangible components of different names and forms, materials and functions, are materialised into various objects, enriching our minds in the process.

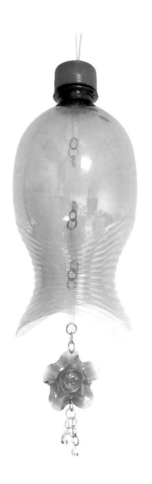

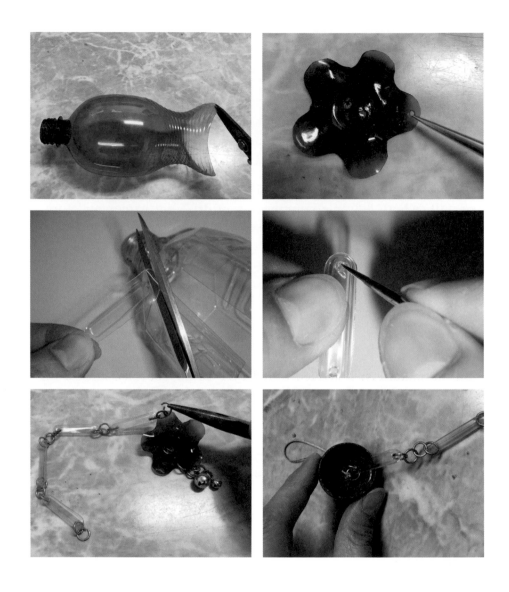

1	2
3	4
5	6

製作步驟

材料：圓形寶特瓶、方形寶特瓶、小鐵圈

1　　依照圓形寶特瓶瓶身紋路裁剪下前半部。

2　　剪下寶特瓶底部，取出花瓣形狀，在其中一片花瓣邊緣中間往內零點二五公分處鑽孔，對稱的一頭也鑽一孔。

3~4　　取方形寶特瓶中間小長框，修剪邊緣成橢圓形，在兩端距外圍零點二五公分處穿孔。

5　　以小鋼圈串連裁片，一端接到花瓣中間的孔，花瓣另一邊加上鈴鐺。

6　　瓶蓋中間鑽兩孔，上下打結固定，串連瓶身及鈴鐺。

Steps of Creation

Required materials: Recycled round PET bottle, recycled square PET bottle, small steel rings

1　　Cut out the lower half of the round bottle according to its grains.

2　　Cut out the bottom portion of the bottle and trim the petal shape piece. Pierce a hole on one end of the petal at 0.25 cm from its edge and same on the opposite end.

3~4　　Cut out the small long frame found in the middle of the square bottle and trim it into an oval shape. Pierce holes at both ends at 0.25cm from the periphery.

5　　The cut pieces are connected in series with small steel rings, with one end connected to the middle of the flower petal, while attaching a bell on the other end of the petal.

6　　Pierce two holes in the middle of the bottle cap, tie dead knots on top and bottom sides of cap. Attach the chain made in earlier step to the cap to complete the wind chime artwork.

花朵胸針

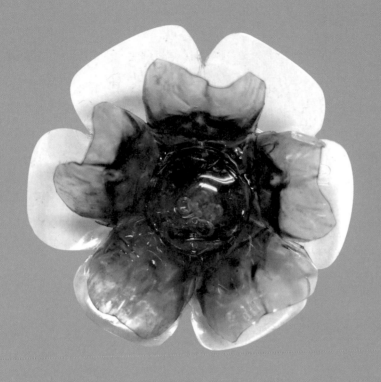

Flower
Brooch

花朵胸針

創意發想／曾雅玲

　　利用各類寶特瓶的質性，一軟一硬、一淺一深，取其深淺色及薄厚度的特性，製作成花朵胸針；兩相搭配不會太剛，也不會太柔弱，恰到好處。以漸層色彩製成的胸花，有如佛法所說「不偏空，不執有，不落二邊，圓融無礙，謂之中道」。

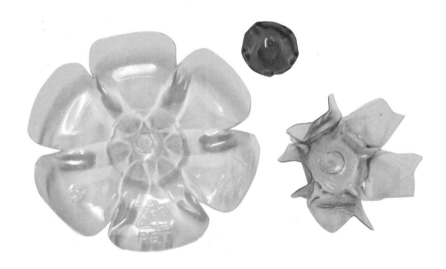

Flower Brooch

Idea Creator / Yalin Tseng

Taking into consideration the various properties of PET bottles, such as its variable hardness, thickness and colour tone, the Flower Brooch design blended all of these characteristics in perfect harmony while striking a good balance between strength and frailty. With all of these traits, the gradient coloured craft piece exhibits the teachings of The Buddha on the way of the "Middle Path", where one's perspective of things are held in a perfect balance and harmony.

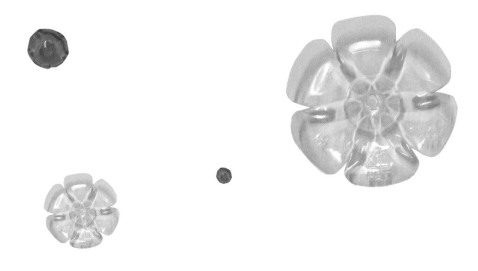

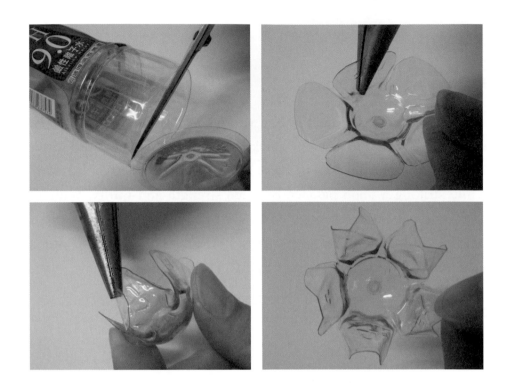

製作步驟 Steps of Creation

材料：底部透明、淺藍、深藍的寶特瓶各一、胸針扣

工具：剪刀、保麗龍膠

1 由寶特瓶底部繞剪一圈取下。

2 取淺藍寶特瓶底，依紋路分五等分，修剪成花瓣形狀。

3 剪完後將五葉花瓣往內扳，再往外扳。

4 用手微調。

Steps of Creation

Required materials: 3 recycled PET bottle bases that are of different colours (clear, light blue and dark blue), 1 brooch pin

Required tools: Scissor, super glue

1 Cut out the base of the 3 bottles.

2 On the light blue colour base piece, cut along each groove into 5 splits and trim out the arc of each flower petal.

3 After which, bend the petals inwards then outwards.

4 Add the final touch with your fingers to craft the flower petal shape.

1	2
3	4

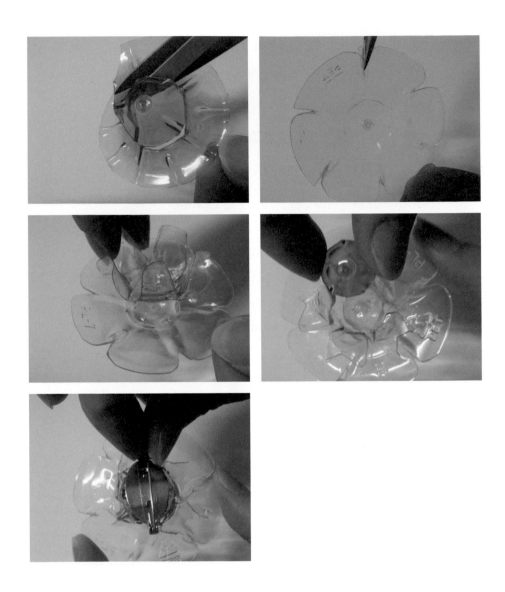

花朵胸針 Flowers Brocch

5 取深藍寶特瓶底，將中心剪下圓形備用。

6 取透明寶特瓶底，依紋路分成六等分剪出花瓣形狀。

7 在透明花瓣中心點塗上保麗龍膠，將淺藍花瓣貼上。

8 在淺藍花瓣塗上保麗龍膠，將深藍圓形貼在中心點。

9 在整朵花瓣背面塗保麗龍膠黏上胸針，作品完成。

5 On the dark blue colour base piece, cut out the circular part from the center.

6 On the dark blue colour base piece, cut along each groove into 6 splits and trim out the arc of each flower petal.

7 Apply super glue in the center of the clear flower petal and stick the light blue flower petal on it.

8 Apply super glue at the center of the light blue flower petal and stick the dark blue cirular piece on it.

9 Apply super glue at the back of the fabricated flower piece and attach the brooch pin onto it to complete the artwork.

5	6
7	8
9	

小花髪飾

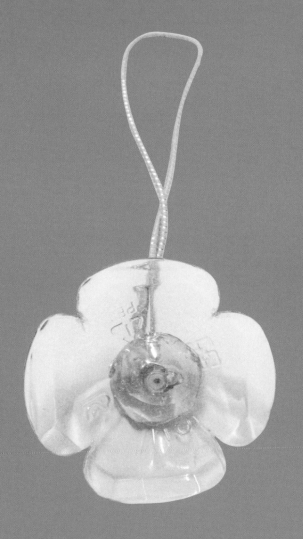

Hair Accessory

小花髮飾

創意發想／曾雅玲

「法應需求而生」，任何物品的形體本具道理，順其形器（應根機）之良能，珍惜再延用。

「價值」起於人的心態，當執著時，即是垢穢，也是無明。人們花費錢財買一時流行，是想要，而不是日常需要，無形中造成浪費；如能善用這些錢財，就能做許多好事。

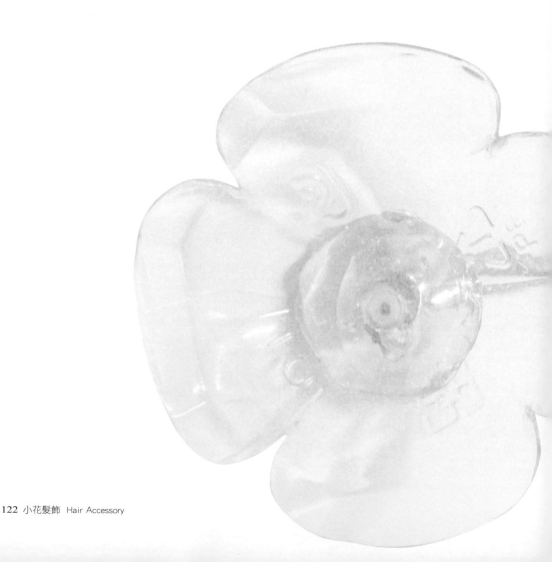

Hair Accessory

Idea Creator / Yalin Tseng

All forms of phenomenon arise from a purpose. Beneath the superficial surface of each object, lies the same theory within as each material item has its own unique functions and features, which can be further utilised accordingly, into extended purposes if cherished.

The perception of value is derived from a person's mentality. Overly persistent in pursuing trendy things often leads to blinding judgment on needs and wants in life, resulting in wastages financially and materially. If these spending are better managed wisely, it could contribute to more good deeds instead.

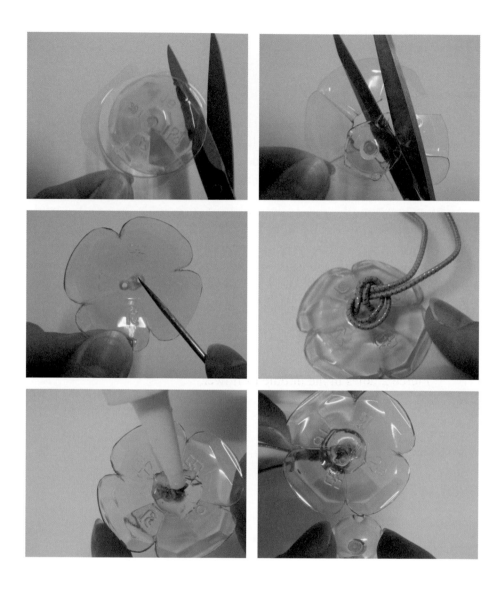

製作步驟

材料：寶特瓶、鬆緊帶、保麗龍膠

1~2 　　取寶特瓶底部，裁剪成花朵形狀和花心。

3 　　在花朵中心兩側鑽孔。

4 　　穿過鬆緊帶，正反面都打上雙結，拉緊固定。

5 　　花心塗上保麗龍膠。

6 　　黏貼在花朵上，完成。

Steps of Creation

Required materials: Recycled PET bottles, rubber band, superglue

1~2 　　Cut out the bottom portion of the bottle into the shape of a flower and centre-piece shape of a flower.

3 　　Pierce 2 holes in the middle of flower,

4 　　Thread the rubber band into the holes and make a double knot, pull and tighten it.

5 　　Lastly, apply superglue to the flower pistil.

6 　　Stick it onto the centre of the flower piece.

1	2
3	4
5	6

腰錬

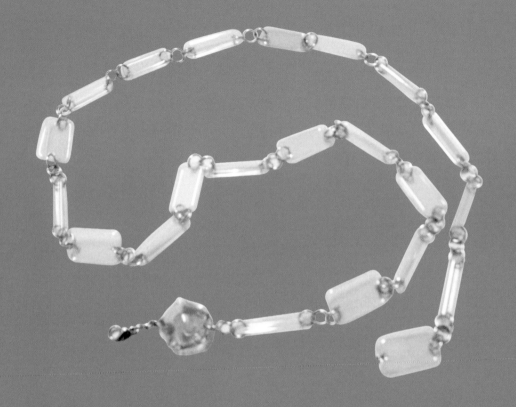

Chain
Belt

腰鍊

創意發想／曾雅玲

寶特瓶還可以做什麼？腰鍊、髮飾、花朵、手提包。

隨順塑膠瓶的彎度、軟硬度、透光性，不加火烤，隨緣順著它的體相，呈現它的美！佛法濟度眾生，環保愛惜物命，尊重大地萬物是道理。

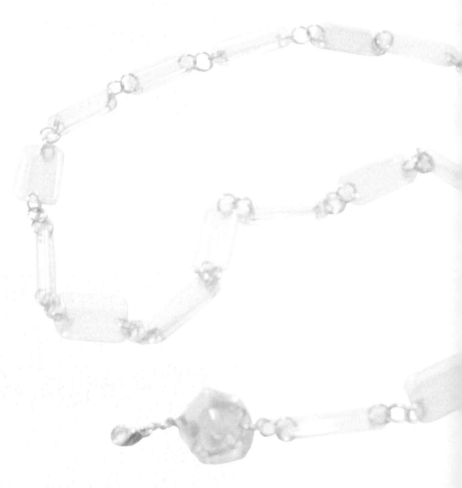

Chain Belt

Idea Creator / Yalin Tseng

Ever wondered what can PET bottles be transformed into? Just to name a few, these bottles can be made into belts, hair accessories, plastic flowers and handbags.

Without changing the properties of plastic bottles, the beauty of its features can be presented through upcycling, where its original flexibility, hardness, transparency, form and shape are utilised accordingly.

This reflects the beliefs of every beings having the potential to achieve greater good, just like in environmental protection where all resources are cherished and functionally maximised. This is the philosophy of respect for all beings and resources.

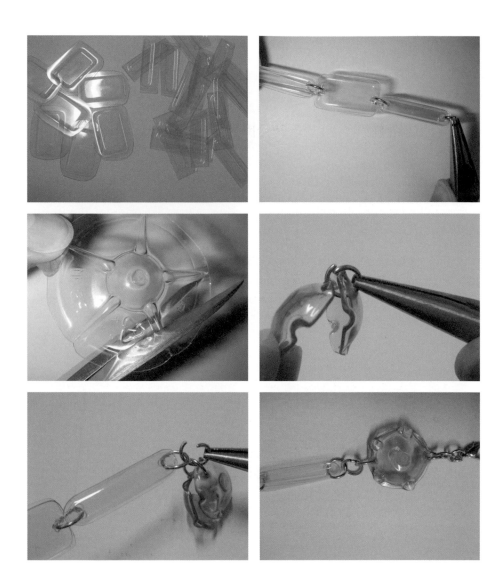

製作步驟

材料：方形寶特瓶、小鋼圈、龍蝦扣

1~2　　取寶特瓶上半部，依紋路修剪成長方形和橢圓形裁片，在裁片兩端距外圍零點二五公分處各穿一個孔，以小鋼圈串連成鍊條。

3~5　　取兩個寶特瓶底部，修剪後於兩側各穿一孔，相合以小鐵圈串連，再連接鍊條。

6　　　圓形裁片另一頭加扣環，完成。

Steps of Creation

Required materials: Recycled square PET bottles, small steel rings, lobster clasp

1~2　　Cut out the top parts of the bottle. Follow the grains on the bottle to trim the pieces into rectangular and oval shapes. Mark 0.25cm from both ends of the plastic pieces and pierce holes on these markings. Chain the pieces of alternate shapes with small steel rings.

3~5　　Cut out the two circular shape base from two bottles. Trim the sides to ensure there are no protruding corners. Pierce holes on both sides of the plastic pieces. Join the two circles facing each other with small steel rings. Chain one side of the piece to the exiting chain.

6　　　Chain the other side of the circular piece to a lobster clasp and the chain belt is completed.

1	2
3	4
5	6

水杯提袋

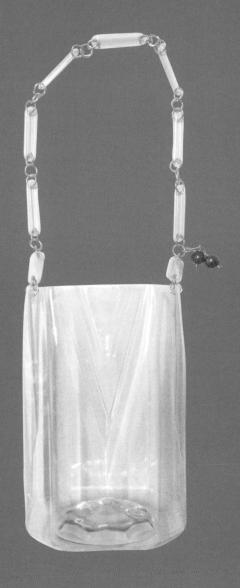

Bottle
Carrier

水杯提袋

創意發想／曾雅玲

　　參與慈濟活動時，時而看見志工們製作多樣吊飾品，用於茶會和會眾結緣，或深入社區多用途善巧利用。

　　於是利用回收寶特瓶試做幾款提袋成品，當陽光灑落時，寶特瓶材質猶如水晶清瑩透亮，不禁法喜充滿，更期待這樣的法喜能和更多人分享。

　　生活周圍很多資源都是寶，倘能把握因緣善加利用，除了能推廣證嚴法師的環保理念，又能愛護大地。祈願更多菩薩，千手、萬萬手，共締善因，護持大愛。無限感恩！

Bottle Carrier

Idea Creator / Yalin Tseng

It can often be seen in Tzu Chi's activities where decorative craft works of volunteers were being given as souvenirs for the participants.

From which, it inspired an idea to craft bottle carriers from recycled PET bottles. One aesthetically pleasing feature of using PET bottles is its crystal-like glow when coming into contact with sunlight, which is not only a joy to watch but one which also evokes the spirit of sharing such joy with others.

In our daily living, there are many valuable resources around us which can be further utilised if we seized such opportunities when it comes by. By doing so, we can contribute towards Master Cheng Yen's call for environmental protection efforts to care for our planet. Hoping that more individuals will come together in upholding such spirit of social kindness and social responsibilities, which is something truly worth being grateful for.

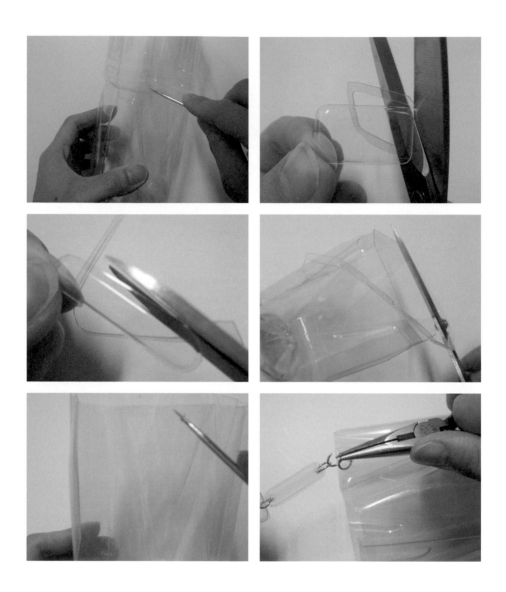

製作步驟

材料：方形寶特瓶、小鋼圈

1~3　剪下寶特瓶上半部，依紋路取出長方形和橢圓裁片。裁片前後距外圍零點二五公分處各穿一孔，以小鋼圈串連成鍊帶。

4　修剪寶特瓶下半部。

5　在開口兩側距外圍零點五公分處各穿一孔。

6　以小鋼圈串連袋身和鍊帶，完成。

Steps of Creation

Required materials: Recycled square PET bottle, small steel rings

1~3　Cut out the upper half of the bottle, follow the groove to cut out one rectangular piece and one oval piece. Pierce holes on both ends of each piece, at about 0.25cm from the edges and connect them up with small steel rings.

4　Trim the lower part of the bottle.

5　Pierce a hole at each opposite side of the bottle opening where it is 0.5 cm from the edge.

6　Lastly, use small steel rings to cascade the carrier and chain together.

1	2
3	4
5	6

風扇掛飾

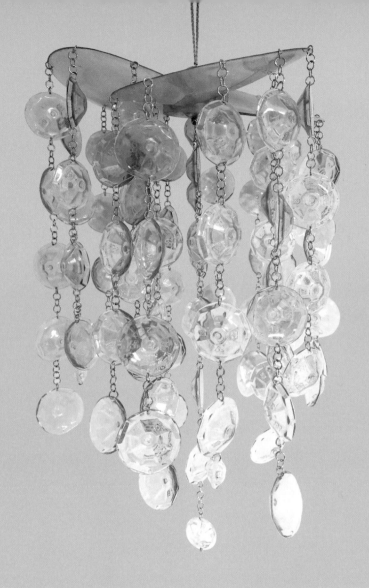

Wind
Chime

風扇掛飾

創意發想／曾雅玲

「價值」在於一念心！

一件物品，掉到地上，沒有利用，使之變成垃圾清掉，就沒有了價值。

運用智慧，愛惜物命，用心撿起來，再應用生活小點子，使它再次發揮物命，也在簡約生活中增長藝術創作。

Wind Chime

Idea Creator / Yalin Tseng

The perception of value lies within one's mentality.

When an item is being discarded without further utilisation, it will lose all its value once it ends up in the trash bin.

Being mindful on treasuring resources, added with a touch of creativity, a discarded item can be upcycled and given a new lease of life, which nurtures artistic creativity while leading to a sustainable lifestyle.

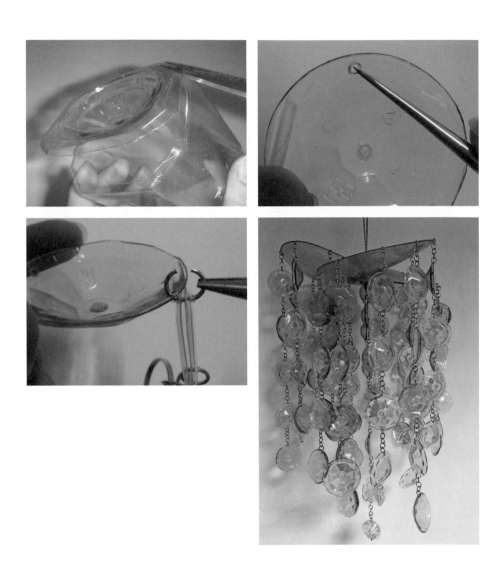

製作步驟

材料：藍色寶特瓶、風扇葉片、小鋼圈

1 取下寶特瓶底部，裁修成圓形。

2 在圓片兩側距外圍零點二五公分處各穿一孔。

3 以小鋼圈串接圓片至所需長度。

4 在風扇葉片上鑽孔，加上寶特瓶片，完成作品。

Steps of Creation

Required materials: Recycled blue PET bottles, fan blades, small steel rings

1 Cut out the bottom part of the bottle and trim it into a circular disc.

2 At each opposite sides of the disc, pierce a hole that is 0.25 cm away from its edge.

3 Use small steel rings as connectors (as shown in the picture above) for stringing up the discs to any preferred length.

4 Drill the required number of holes on the fan blades and secure each string of discs to it. Artwork is completed.

1	2
3	4

掛衣架

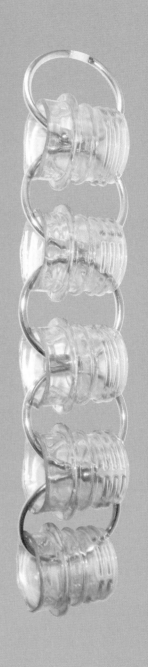

Hanging Organiser

掛衣架

創意發想／曾雅玲

修行者一定了解「無為法」是最實用的。

日常生活中帶著「滿足」的心，東西有得用就好，不必求新、不必求變；不是在比貴，而在實用，所要用的是有用之物，就是最寶貴的。

這是修行者的心，知足常樂就是福！

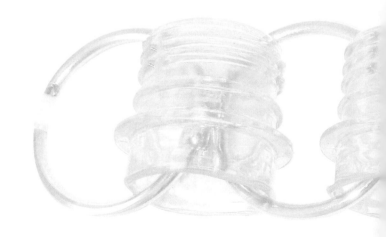

Hanging Organiser

Idea Creator / Yalin Tseng

In Buddhism, spiritual practitioners are known to comprehend the importance of positive thoughts.

In our daily living, if we live with contentment, valuing "needs" over "wants", functionality over materialism, then all that we require will be all that we need. Such is most treasurable.

This is the value of a true practitioner, having contentment is also a true form of blessing.

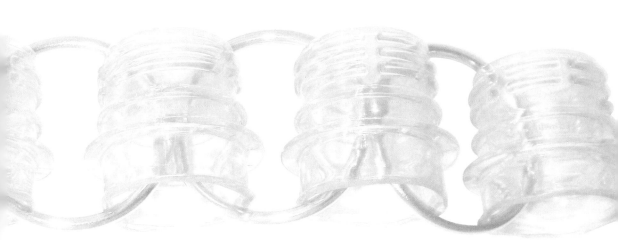

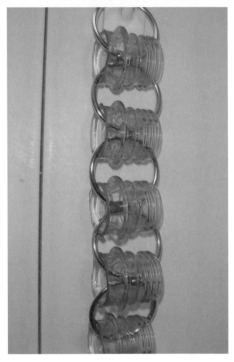

製作步驟

材料：寶特瓶、鐵環扣

1　　取下寶特瓶口。

2　　修整邊緣。

3　　以鐵環扣串連至所需長度。

4　　完成品。

Steps of Creation

Required materials: Recycled PET bottles, steel binder rings

1　　Cut out the bottle neck.

2　　Trim the edges.

3　　Chain to the required length with steel binder ring.

4　　Completed artwork.

1	2
3	4

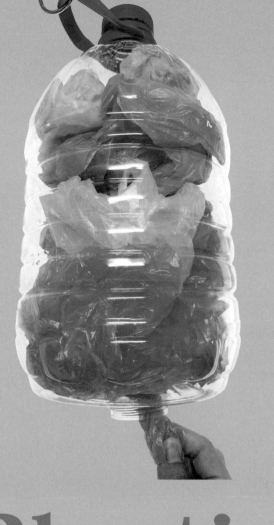

Plastic

Bag

Organiser

收納袋

創意發想／曾雅玲

應用寶特瓶外型特性，兩個半弧形促成一個圓，各各平等，本具清淨圓融！

有為法導向善道，家家清淨在源頭，環保落實在家家戶戶。小小的心願，也能夠影響大大的環境。

證嚴法師曾開示：「有為法，也就是無漏的心力，戒定慧後身體力行，大家做得很歡喜。環境清淨了，大家的心也歡喜了，就是『證真空涅槃寂靜之樂』。」

Plastic Bag Organiser

Idea Creator / Yalin Tseng

Utilising the distinctive shape of PET bottles, combining two identical and equal portions to form into a rounded container, depicting the essence of harmony.

Sustainability at source starts from each families' efforts. The smallest aspiration can create significant impact to the environment.

Master Cheng Yen said: The right way to achieve happiness, is through the strong spiritual strengths of precepts, enlightenment, and wisdom. If one achieves sustainability at root point, one will have a joyful heart which is the state of nirvana.

收納袋 Plastic Bag Organiser

製作步驟

材料：兩公升礦泉水寶特瓶兩個

1 取 A 寶特瓶在底部挖圓孔。

2 剪下 B 寶特瓶瓶口。

3 在A瓶底部裝上B瓶口。

4 完成品。

Steps of Creation

Required materials: Two recycled PET bottles (capacity: 2 litre)

1 Cut a small hole at base of Bottle A.

2 Cut out the bottle neck part of Bottle B.

3 For the final step, attach Bottle B neck piece onto the base hole of Bottle A.

4 Completed artwork.

1	2
3	4

脚底

按摩塾

底

Foot
Massage
Pad

腳底按摩墊

創意發想／曾雅玲

從事資源回收的過程中，發現寶特瓶底部材質堅硬，環保菩薩踩踏不扁，進而發想應用在日常生活中。

證嚴法師曾開示，要「延緩失智」唯有「做環保」。

環保菩薩從做環保中，認識各類資源如何區分（形體、顏色、材質……等），從付出當中「集識成智」，將知識轉化成智慧，大腦中不雜亂、不懈怠、心無雜念，即如「靜思語」所言：「安心睡、快樂吃、歡喜笑、健康做，是人生四寶。」

Foot Massage Pad

Idea Creator / Yalin Tseng

From the process of recycling collection, volunteers discovered the base of the PET bottle to be strong and not easily squashed. This inspired them to further explore on creating lifestyle ideas with it.

Master Cheng Yen once said during her Dharma session, the only way to delay dementia is to do recycling work.

Engaging in recycling work, the volunteers learned to differentiate various resources (shape, colour, material, etc.), and it is through giving of time for a good cause, one is able to transform the knowledges gathered from it into wisdom. In such, our minds will be clear, our brains will not be cluttered and sluggish. This exemplified one of the Jing Si Aphorism (words compiled from dialogues between Master Cheng Yen and her disciples or visitors) : "Sleeping peacefully, eating happily, laughing joyfully, and working healthily, these four are treasures in life."

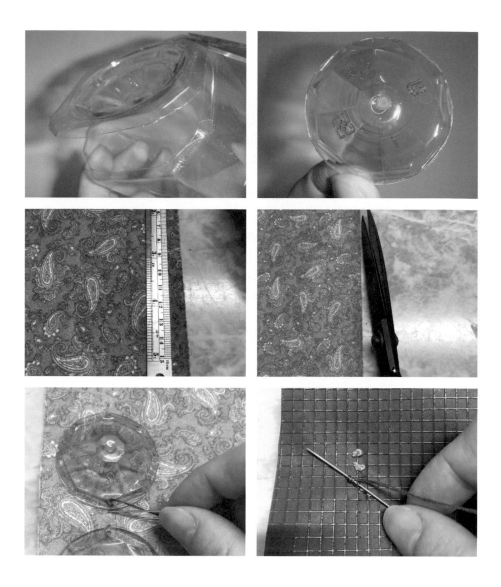

製作步驟

材料：寶特瓶底、回收地墊

1 取寶特瓶底部，裁剪成圓形。

2 在圓片兩側距邊緣零點三公分處各鑽一小孔。

3 在回收地墊上畫出所需尺寸。

4 裁剪。

5 以針線將寶特瓶圓片縫在地墊上。

6 於背面打結，按摩墊完成。

Steps of Creation

Required materials: Recycled PET bottle, recycled floor mat.

1 Cut the base of the bottle into a round shape.

2 From the edge of 0.30cm, pierce a small hole on both side of the bottle base.

3 Draw the required measurement on the floor mat.

4 Cut it out.

5 Sew the round bottles bases onto the mat with needle.

6 Thread to complete the artwork.

1	2
3	4
5	6

相遇重生

冰與火的

Rebirth - Where Fire and Ice Meets

水老鶴

Water Crane

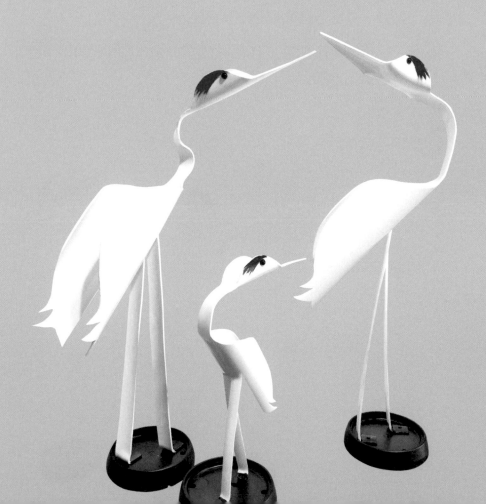

水老鶴

創意發想／鄭明宗

「水老鶴」的故事取自佛典，證嚴法師的解釋是教人了解生與死。

慈濟臺南善化靜思堂啟用在即，看到這麼莊嚴的建築物從地湧出，於是構思在前庭裝置造景來映襯，想著想著，腦中浮現自古以來的吉祥動物「鶴」，閩南語發音不就是「好」嗎？

主意既定，又在環保站看到各式各樣的廢棄水管，萌起動手做做看的念頭。利用空暇時間不覺間完成了幾隻作品，倒也相得益彰融入場景，歡喜吉祥的模樣令人開心。

後來，想到這個作品是不是也可以在日常生活中應用？就將鶴的身體稍作變化，創作了「鶴面紙盒」。

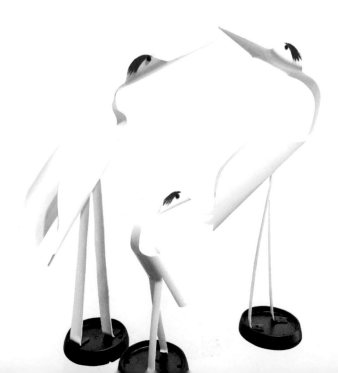

Water Crane

Idea Creator / Cheng Ming-tsung

The tale of "Water-Heron" is a story originated from a Buddhism illustration on life and death as explained by Master Cheng Yen.

As the launching of Tzu Chi Tainan Shanhua Jing Si Hall draws nearer, looking at the newly raised building, an idea came to mind to complement the majestic-looking structure with a front yard decoration. After some thoughts, "crane" came to mind; Since ancient times, cranes are considered as auspicious animals; Coincidentally, the pronunciation of "crane" in Mandarin has a similar pronunciation as "good" in Taiwanese dialect.

Once the idea was established, various shapes and sizes of disposed PVC pipes were also sighted at the recycling centre. With these materials, a few water crane installations were successfully handcrafted. The completed artworks blended perfectly into the landscape, while adding joyful and auspicious vibes into the area.

Subsequently, this led to a thinking of integrating them into practical household items which can be used in our daily living. Hence the design was modified and transformed into a "Water Crane Holder".

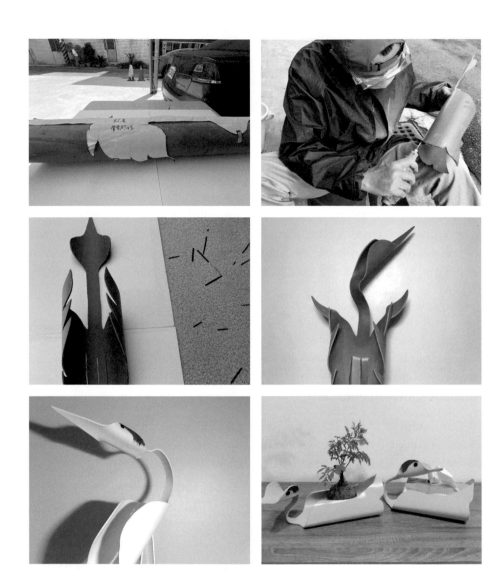

製作步驟

材料：PVC塑膠管

工具：電動切割機

1　　將紙圖版放置在水管上描繪樣版。

2　　以電動工具裁切。

3~4　火烘塑形，加上底座。

5　　漆上底色，再上身體白漆、腳部黑漆，點上眼睛和紅色頭羽，靜置乾燥。

6　　成品展示及面紙盒改造。

Steps of Creation

Required materials: Recycled PVC pipes

Required tools: Electric cutter

1　　Place the crane design template on the pipe and trace the outline.

2　　Cut the pipe with an electric cutter.

3~4　Use heat to craft the pipe into a crane shape and attach it to a base.

5　　Apply primer (base colour) on entire surface, next paint the crane body in white, legs and eyes in black and head feather in red. After leave it to dry.

6　　Showcase of Water Cranes installations and Water Crane Holders.

1	2
3	4
5	6

菩提葉

Bodhi Leaf

菩提葉

創意發想／鄭明宗

「金菩提葉」的閩南語發音，類似「真正有菩提心」。

利用回收水管製作菩提葉，水管的厚度不拘，更可以廣泛延展物命，發揮成為生活小品。可依個人喜好、興趣，搭配環境需要漆上各種色彩，就有畫龍點睛的效果。

Bodhi Leaf

Idea Creator / Cheng Ming Tsung

Taiwan's local dialect pronunciation of "Golden Bodhi Leaf" has similar meaning as "the awakened heart" in Chinese.

The process of crafting the Bodhi Leaf ornament involves the upcycling of recycled PVC water pipes that are of any thickness, coated with any colour paint of choice as an embellishment to the final artwork.

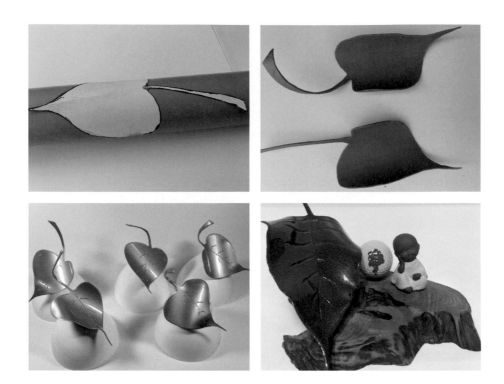

製作步驟

材料：PVC塑膠管、漆

工具：電動切割機、菩提葉紙圖、油漆刷

1 將紙版圖樣放置在水管上。

2 以電動工具裁切樣版。

3 漆上喜歡的顏色，並懸掛待乾。

4 油漆乾燥後，依喜好擺設。

Steps of Creation

Required materials: PVC water pipes, paint

Required tools: Electric cutter, Bodhi leaf paper template, paint brush

1 Place the bodhi leaf paper template on the water pipe.

2 Cut the pipe with an electric cutter.

3 Paint them with any colour preference and hang it to dry.

4 It can be used further and made into beautiful ornaments.

1	2
3	4

想師蓮

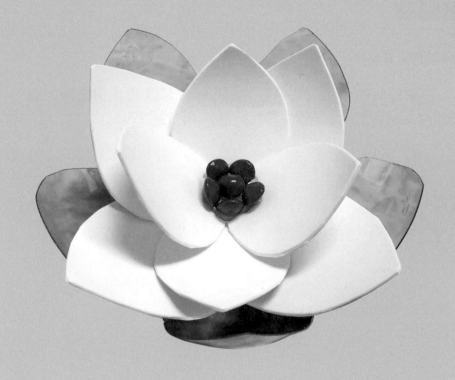

The
Sentimental
Lotus

想師蓮

創意發想／曾雅玲

　　證嚴法師開示：「有正確的觀念，才能斷盡一切煩惱；要有很深厚、縝密的信心，才有辦法受持一切的法門。」

　　一只花朵的呈現，需歷經刀具不斷地修剪與琢磨，方能成型，猶如「因圓趨果」。我們若能入人群學習，用心體會，追求真理，行六度行，以佛心對待一切眾生，則每一個眾生均是我們造福的對象，才能粒粒累積，圓融成熟，歸於果來。

The Sentimental Lotus

Idea Creator / Yalin Tseng

As Master Cheng Yen once said, if one can uphold right perceptions in life, only then can all afflictions be removed; if we have an unwavering faith in the path of cultivation, we will be able to uphold these practices.

Just like the crafted lotus flower that needs to undergo a series of trimmings before it becomes presentable, similarly our path towards moral cultivation requires enrichments from our living environment, amongst the multitude of people, where we can find fruitful opportunities to serve and learn with an awakened heart.

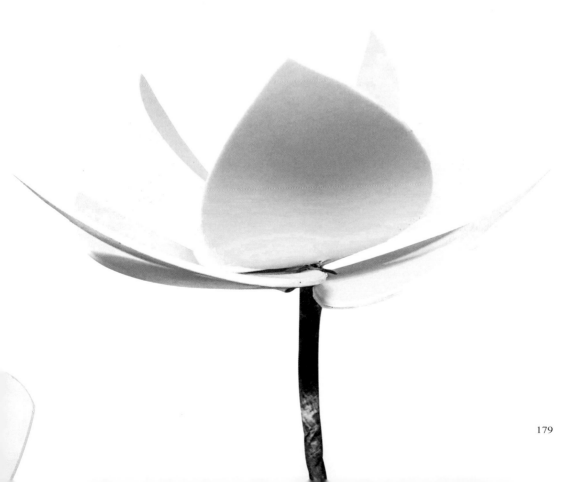

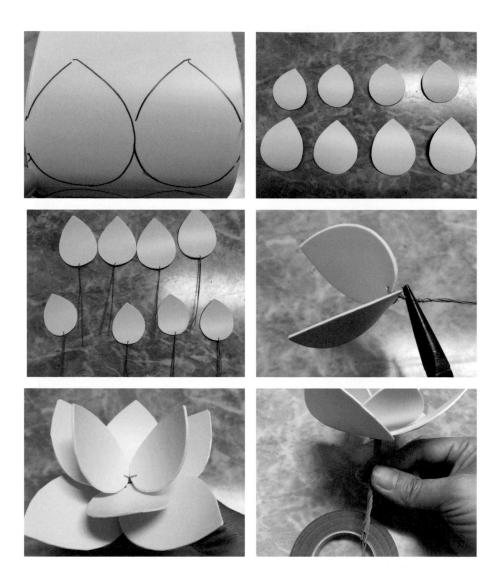

製作步驟

材料：HDPE塑膠瓶、寶特瓶、想師豆（相思豆）、鐵絲、綠色紙膠帶、 膠水

工具：鑽子

1	以HDPE塑膠瓶剪出水滴型花瓣，
2	大小各四片。
3~4	以鐵絲將花瓣先小後大一片片結合。
5	形成蓮花。
6	鐵絲以綠色紙膠帶整合。

Steps of Creation

Required materials: HDPE plastic bottle, PET bottle, Acacia beans, metal wire, green paper tape, glue

Required tool: Drill

1 From the HDPE plastic bottle, cut out flower petals in the shape of a water droplet.

2 4 pieces each for big and small size.

3~4 Use a metal wire to tie the petals together one by one, first for the small petals, and then the big petals.

5 Form Lotus.

6 Wrap the end of the wire with green paper tape.

1	2
3	4
5	6

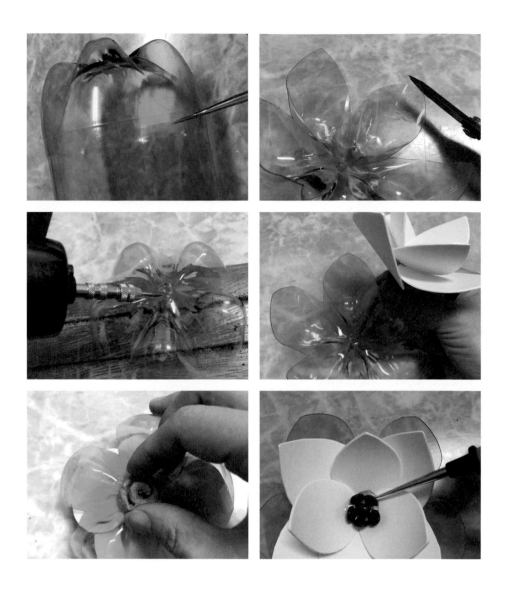

7　　　　取下綠色寶特瓶底。

8　　　　剪出蓮花葉片。

9　　　　在葉片底部中心鑽洞。

10　　　插入蓮花。

11　　　固定底部。

12　　　蓮花中央黏上想師豆，完成作品。

7　　　　Cut out the base of a green PET bottle.

8　　　　Trim it into the lotus leaf shape.

9　　　　Drill a hole in the centre of the leaf.

10　　　Put on the lotus petals.

11　　　Fix it at the bottom of the leaf.

12　　　Glue a few Acacia beans on the centre of the flower petals and the artwork is completed.

7	8
9	10
11	12

菩提樹

Bodhi
Tree

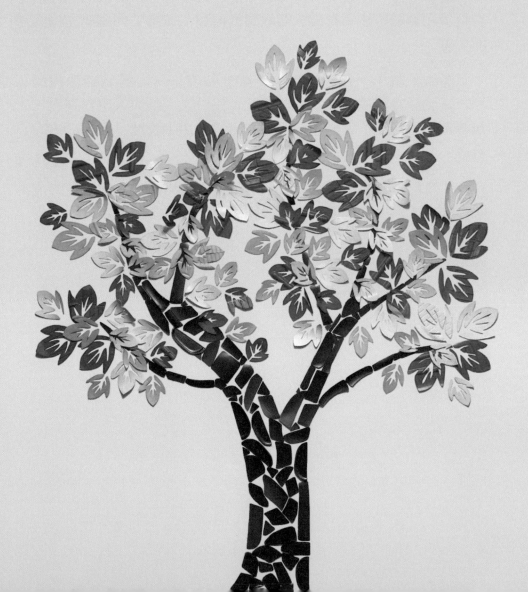

菩提樹

創意發想／曾雅玲

　　創作的動機，來自於證嚴法師常提到「來不及」，這句話就像一聲響鐘，敲醒我，捫心自問能做些什麼？該如何把握生命良能去付出？

　　從那時起，我觀察周圍物品的特性與構造，相信天地萬物都有特質和無限可能，打破一切框架後再製，並將它們擺放在適當的位置。

　　佛法所謂「一花一世界，一葉一如來」，心靈若能保持清淨，達到靜寂清澄的境界，舉凡行、住、坐、臥與人應對進退，無不都在「行經」。無量法門本在日常生活中實踐，發揮最大的效應。

　　「淨化己心的『心室效應』，是用來對治溫室效應最好的方法。唯有人與人之間多一分互愛與感恩，人人對天地環境、萬物生靈多一分疼惜與愛護，才能四大調和、山河平安。」證嚴法師如是說。

　　資源隨手丟棄就成為垃圾，但若有心製作留下來，將助益人群，資源也將生生不息。

Bodhi Tree

Idea Creator / Yalin Tseng

The idea of this creation was inspired by Master Cheng Yen's frequent reminder on utilisation of time, something that is depleting even as we speak, and hard to keep up. Thus, the question came to mind: how can we make the best out of our given time and bring more purpose to it?

From that moment, I observe the characteristics and structure of the surrounding objects and believe that all things in the world have unique characteristics and infinite potentials to be explored. With that, it breaks all self-perceived limitations and inspired the creation of this artwork as well as its utilisation.

In the context of Buddhism, there is an analogy on macrocosm and microcosm which reminds us that even from the most subtle of actions in our daily living, be it in motion or stationary, it can be in symphony with moral philosophies when the mind is tamed and at peace, reaching the heights of spiritual clarity.

The best remedy to global warming might just be in the pacification of our very own inner afflictions. As per Master Cheng Yen's discourse, when there are gratitude and kindness between one another, when we respect, cherish and care for our environment, only then the world will be in true harmony.

Resources becomes trash If we neglectfully dispose them. However, if we can be mindful in reusing them, they can be beneficial to the society and resources will constantly be in supply.

製作步驟

材料：咖啡色塑膠瓶、綠色塑膠瓶

1 利用紙圖版在塑膠瓶裁片上畫出大小葉片，裁剪下來。

2 可混用不同綠色的瓶子。

3 利用咖啡色塑膠瓶剪出樹幹，貼上葉子即完成。

Steps of Creation

Required materials: Brown and green plastic bottles

1 Use leaf shape paper template of different sizes to trace on the bottle, then cut them out.

2 Suggest using different shades of green bottles to create the leaves.

3 Cut out the tree trunk from the brown bottles. Paste the green leaves on it and artwork is completed.

1	3
2	

Alocasia Flower

海芋

創意發想／曾雅玲

「一切眾生皆有真如佛性」，成佛的機會人人都有，就像任何物品的內在，都有它該完成的真理，每件東西都有它的質、性、理，才能夠製成不同的物體，應人使用。每一項物品都有它的理，都是寶，但是不要它、毀壞掉、隨意丟棄，其中的道理也跟著被忽視掉，再也發揮不了它的功能。

製作浴佛「想師蓮」作品時，沒用到的塑膠瓶把手，猶如藏在垃圾堆中的寶，依它特有的形狀稍微修剪，組裝即成為美麗的「海芋」。

發揮生活巧思，創意沒有標準，只要能應用均是寶！

Alocasia Flower

Ideal Creator / Yalin Tseng

All sentient beings have Buddha nature in them and has the same potential to awaken the enlightened nature within. Just like in any item, has in it a purpose to fulfil. An item is a combination of different element, nature and characteristics which can be materialised into different objects to suit different needs and usages. Having its own unique values, each of them is treasurable. However, if we discard them at will, it will lose its value and functionality.

In the process of making the "The Sentimental Lotus" for Tzu Chi's Buddha Day Ceremony, the unused handles from plastic bottles are like diamonds in the rough, as they transform into beautiful Alocasia flowers after being crafted.

There are no standards or guidelines to creativity, exploring with daily lifestyle ideas, things become valuable.

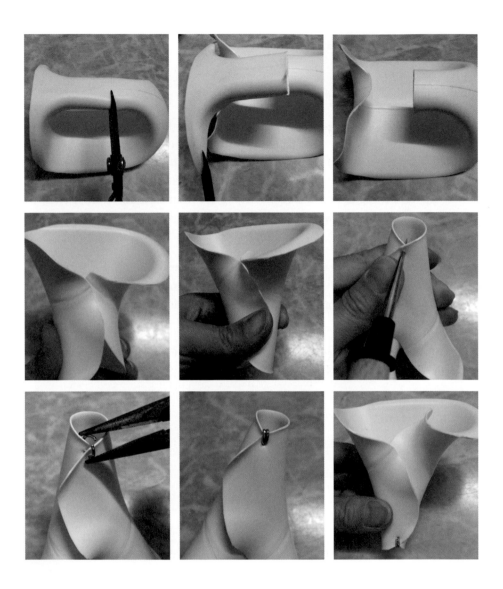

製作步驟

材料：洗衣精塑膠瓶、小鐵圈、塑膠袋、鐵絲、熱融膠條、紙膠帶

工具：剪刀、鑽子、尖嘴鉗

1　　　剪下洗衣精瓶把手，從中間截開。

2~3　　再從另一側截取下來。

4~5　　從較窄一邊捏緊。

6　　　重疊處鑽孔。

7~9　　以小鋼圈固定。

Steps of Creation

Required materials: Recycled plastic detergent bottle with handle, small ring, recycled plastic bag, wire, hot glue stick, paper tape

Required tools: Scissor, bradawl, noose piler

1　　　On the cut-out handle of the bottle, make a slice in the middle.

2~3　　Cut it out from the side.

4~5　　Compress the portion that is narrower until the two sides overlap one another.

6　　　Use the bradawl to pierce a hole on the overlapped area.

7~9　　Secure with a small iron ring.

1	2	3
4	5	6
7	8	9

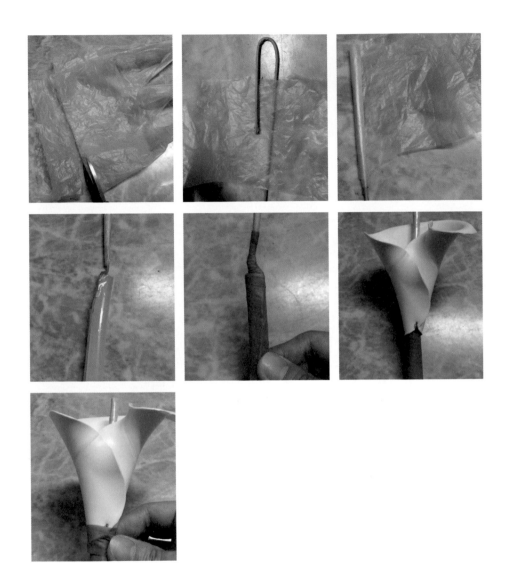

10 回收塑膠袋剪下五公分長條。

11 將鐵絲反折勾住塑膠袋片。

12 捲成花蕊。

13 以熱融膠條作花莖。

14 用紙膠帶和花蕊固定。

15 加上花朵。

16 花朵底部以紙膠帶固定即完成。

10 Cut out a 5cm-long strip from the plastic bag.

11 Use it to roll up the folded wire.

12 Into a flower stamen.

13 Use hot glue stick as the flower stem.

14 Place the flower stamen on it and wrap with the paper tape to secure them together.

15 Lastly, slot in the flower.

16 Secure from the bottom part of it using paper tape.

10	11	12
13	14	15
16		

點翠飾品

Kingfisher Feather Ornament

點翠飾品

創意發想／曾雅玲

　　「點翠」是傳統金屬工藝和羽毛工藝的結合。「翠」即翠羽，取自保育類動物翠鳥的羽毛，以翠藍、雪青為上品。

　　製作點翠首飾時，工匠先用金或鎏金的金屬做成不同圖案的底座，再把活翠鳥的藍色羽毛拔下鑲嵌在底座上，非常殘忍！

　　作為傳統的金銀首飾製作工藝，由於工藝複雜，成品難以保存，這項傳統工藝幾乎失傳。

　　只有在故宮博物院才能見到的東方失傳工藝，慈濟人藉以「撿福」環保回收物再利用，救生護生不殺生。

Kingfisher Feather Ornament

Idea Creator / Yalin Tseng

"Dian Cui" or "Dotting with Kingfisher Feathers" is a form of traditional Chinese art, combining metal and feather craft. "Cui" refers to feather of the kingfisher, a protected bird. Emerald blue and snowy green feathers are the most precious of its kind.

When making the jewellery, the craftsman will first use gold or similar metals to form the base. Following which, he will pluck the feathers of a live kingfisher and engrave them to the base. This is extremely cruel!

As a form of traditional art, the skill was nearly lost due to the complexity of the crafting process and difficulty of preserving the jewellery.

You can only see these rare ornaments in the National Palace Museum nowadays. Tzu Chi volunteers preserve this skill by upcycling recycled materials without harming a single animal.

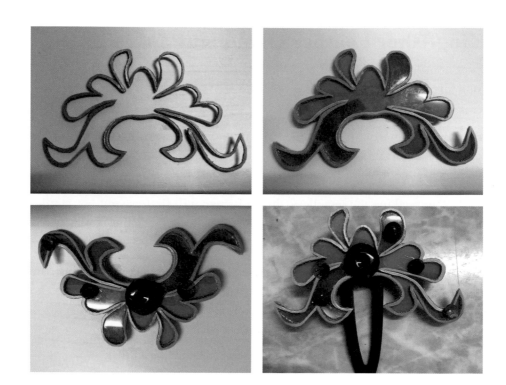

製作步驟

材料：HDPE瓶

1 雕刻出點翠外框。

2 底部黏上寶特瓶片。

3 貼上深藍寶特瓶片、珠珠點綴。

4 底部可加髮夾成為頭飾。

Steps of Creation

Required materials: Recycled HDPE bottles

1 Carve out the outline with.

2 Paste the cut pieces of dark blue bottles to the base

3 Decorate it with beads.

4 It can also be turned into a hair accessory by adding hair clip on the bottom.

1	2
3	4

蝴蝶髮飾

Butterfly
Hair Bow

蝴蝶髮飾

創意發想／曾雅玲

　　證嚴法師諄示：「見外之形，不知內含是物理，萬物深含本具之道理。」

　　發想作品時，常拿著各類回收品擺放在視線範圍內，與其「交心對話」，直到想出來如何應用。

　　在想出洗髮精瓶身如何運用之後，會留下了「擠壓頭」，按照一直以來的思考方式，深信它的結構特性（道理）一定可以製成某個生活用品。

　　雖然這些資源沒有生命，但它們不僅是從大地開採，製作過程也相當繁複。

　　現代社會一次性商品被廣泛製造，商人們研發各式各樣的物品，多樣化的造型各具不同質性：方形、圓形、軟硬度，因此想利用物品本身的形體構造，在沒有燒、烤的二次汙染下，再度延續物命，功能再利用。

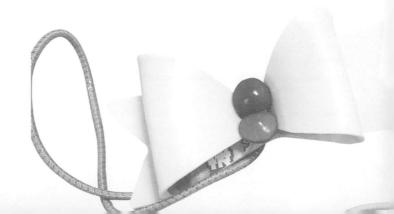

Butterfly Hair Bow

Idea Creator/ Yalin Tseng

As per Dharma Master Cheng Yen's teaching – "There is a philosophical principle hidden within every material thing and which, cannot be uncovered just by looking at the external form of it".

During the idea creation, the collected recyclables were observed carefully and literally having a "Heart to Heart Dialogue" with them before arriving at an idea.

After figuring how to make good use of the shampoo bottle, there is still a "shampoo pump" which is yet to have a usage. By using a similar thought process and a strong faith on the unique structure ("Principle") of the "shampoo pump", it will surely can be made into an useful item for our daily living.

Although products are lifeless in nature, they are originally extracted from Mother Earth and underwent complex processes to become finished products.

In today's society of convenience, there are wide varieties of disposable products being manufactured in abundance, and incineration of these used products brings about additional pollution. Hence recycling of used products will extend the lifespan of the extracted resources and continue to serve another product cycle.

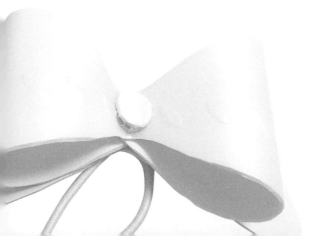

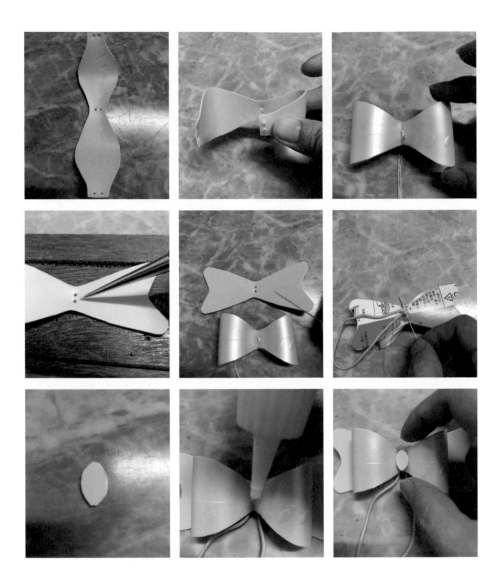

製作步驟

材料：HDPE洗髮精瓶、鬆緊帶、針線

1 取塑膠片剪出八字弧形狀，在中心和兩側各鑽兩孔。

2~3 由外往內折，以針線縫緊固定。

4~5 取其他顏色塑膠片，剪出蝴蝶結底片。

6 將鬆緊帶縫在蝴蝶結背面。

7~9 剪小圓片，黏貼在蝴蝶結中心，完成。

Steps of Creation

Required materials: Recycled HDPE shampoo bottles, elastic band, needle, thread

1 Use a piece of recycled plastic, cut it into a shape of an "8", make two holes in the center and on both edges.

2~3 Fold inwards then use a thread to hold them in shape.

4~5 To make the backing of the butterfly hair bow, choose a different coloured plastic and cut it into the shape of a butterfly.

6 Sew an elastic band at the back of the butterfly hair bow.

7~9 Cut a small piece of used plastic into a round shape, stick it to the center of the bow and the butterfly hair bow is completed.

1	2	3
4	5	6
7	8	9

馬卡龍吊飾

Macaron Ornament

馬卡龍吊飾

創意發想／曾雅玲

　　證嚴法師開示：「人類長久以來，世代累積，一代比一代欲念更大，一代比一代物欲更重，所消費的東西愈來愈多。東西消費後會產生很多垃圾，垃圾造成惡濁、骯髒的東西，無論是埋在地裏、用火燒掉，在在破壞大地、汙染空氣。所以空氣受汙染了，自然大地氣流就不調和。」

　　在環保DIY製作過程中，即使瓶瓶罐罐已經大致應用，仍會有剩餘的一些小碎片與碎粒，慈濟人仍是愛惜回收，回歸清淨源頭，以這些「有為」的小物，帶出「無為」的環保教育精神為出發點，進而又誕生了新作品。

Macaron Ornament

Idea Creator / Yalin Tseng

Master Cheng Yen said: Over many generations, human desires have multiplied and materialism on the rise. The over consumption increases waste and resulting in pollutions. Regardless if they are buried in landfills or incinerated, they will still contaminate the soil or pollute the air. Air pollution negatively affects the ecosystem.

In the process of making DIY handicrafts with recyclable materials, there will still be unused fragments resulting from it although the bulk of it had been utilized. Being as they are, Tzu Chi volunteers would cherish these fragments, guided by the concept of "Sustainability at Source" to turn them into another artwork. Originating from intangible thoughts of advocating environmental awareness, these tangible fragments are used to exemplify the spirit of which.

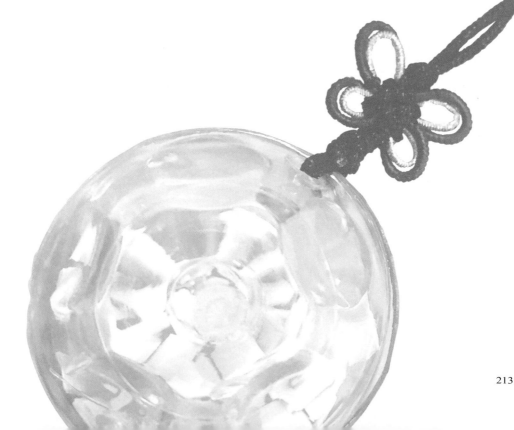

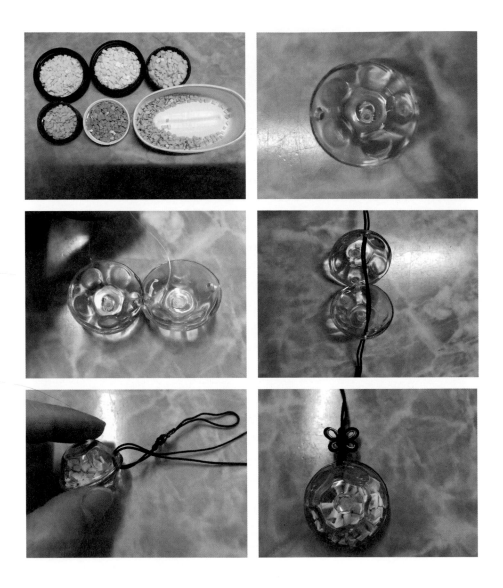

製作步驟

材料：透明寶特瓶兩支、洗潔精瓶剩餘材料

1 利用洗潔精瓶剩餘材料，剪成小碎片。

2 取透明寶特瓶圓形底部兩個，上下各穿一孔。

3 以透明線串連兩者。

4 另兩孔穿入中國結線。

5 將塑膠片放入其中。

6 將中國結拉緊打結，完成。

Steps of Creation

Required materials: 2 recycled transparent PET bottles, Recycled HDPE bottles leftover fragments

1 Cut the leftover colorful bottle fragments into flakes.

2 Cut out the round bottom part of the two bottles, and make holes on both ends of each piece.

3 And bind one side of each together with a transparent string which will form an open capsule.

4 Loop a Chinese knot string on the other two holes

5 After which, put the flakes into it, to seal up the capsule.

6 And tighten it to complete the artwork.

1	2
3	4
5	6

掃貝架

Broom Gripper Rack

掃具架

創意發想／曾雅玲

　　形體本具道理，順其型器（應根機）良能，珍惜再延用。

　　想想這款塑膠瓶像什麼呢？只要拿起剪刀，順著接連瓶身的把手剪下來，再將中間剪裁成一直線，就可以變身成為掃具架！是不是簡單又好用呢？

Broom Gripper Rack

Idea Creator / Yalin Tseng

Utilising the charateristics of detergent bottles, along with a few trims and cuts, a simple yet useful broom gripper rack is seamlessly created.

What does these plastic bottles resemble? With just a scissor, cut out the handle accordingly, make a cut in the middle and it becomes a broom rack!

Ain't it simple yet useful?

製作步驟

材料：PE清潔劑瓶、螺絲釘、木板

1　　取下瓶子把手。

2　　修整邊緣。

3　　在把手外緣取中線剪開

4　　修整尖角。

5　　以螺絲釘固定在支架上。

6　　完成品。

Steps of Creation

Required materials: PE detergent bottles , screws, wooden plank

1　　Cut out the detergent bottle handle.

2　　Trim the edges.

3　　Cut along the line in the middle of the handle's outer layer.

4　　Trim off the sharp edges.

5　　Screw both ends of the cut out handle onto a wooden plank

6　　The process is completed.

1	2
3	4
5	6

大地共榮

尊重重生命

Coexist with Our Planet - Respecting Lives

動物園

環保

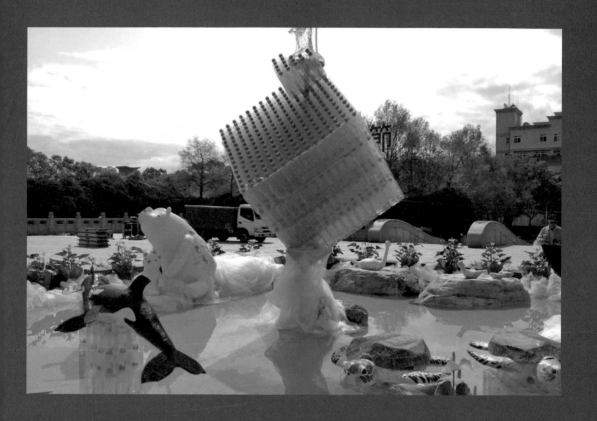

Eco Zoo

環保動物園

創意發想／周秀琴團隊

　　這是一個全新的嘗試，利用回收的塑膠籃來製作動物模型。選擇先以豬做試驗，是因為豬的體形適中，一旦有了基本做法和主要素材，其他大型動物就能依法製作。因此，周秀琴團隊先完成第一隻豬的雛型，觀察、思量幾日之後，再拆解重做。

　　豬的軀體架構由數個圓形塑膠籃以束帶固定拼接完成後，再利用回收PE泡棉柔軟的特性當作肌肉，包覆修飾外觀線條。以紙管當腳，穿到塑膠籃裏，用束帶固定，「豬」就站起來了！

　　上了紙漿的豬有了皮膚，形體模樣也更加清晰。大家先上網學習紙漿的製作方法，反覆調和碎紙漿和白膠，試出最佳配比；關鍵祕訣是擠掉碎紙漿的水分，加入白膠後不能使用攪拌工具，而是用手感覺紙漿的濃稠度。

　　以回收素材創作的動物玩偶，有企鵝、鯨魚、長頸鹿、大象、北極熊、石虎、蜜蜂、黑熊、海豚、螢火蟲和豬。這是周秀琴帶領九位志工集合智慧巧思，耗費一個多月的時間合作完成。雖仍有不盡人意的地方，但在實驗和失敗中獲取的經驗，是最寶貴的收穫。

Eco Zoo

Idea Creator/Zhou Xiu-qin's team members

It was a new attempt to use recycled plastic baskets for making models of animal. The first chosen experimental model was pig because of its more neutral shape and size. Once the basic method and required materials were established, similar method could be adopted for creating other bigger animals. This first prototype was examined and reviewed for a few days before it was dismantled and rebuilt.

The structural frame of the pig model was built by assembling a few round plastic baskets which are firmly secured by wire ties, before wrapping up with spongy PE foam sheet to form the body. The characteristics of spongy foam sheet resembles the flesh texture and also contour of the animal.

The pig model can finally stand on its own, with legs made of paper tubes which were inserted into the plastic baskets and firmly secured by wire ties.

After applying paper pulp to form the skin, the bodily feature of the pig model is now more distinctive. The team self-learns the pulp production method from the internet. Different proportions of shredded paper and white glue were experimented to obtain the best mixing ratio. Key success of the paper pulp production is squeezing out excess water from the shredded paper paste and mixing by hands after adding glue instead of using a mechanical blender, to have better feel on the pulp thickness.

The animal models that were created by using recycled materials include penguins, whales, giraffes, elephants, polar bears, leopard cats, bees, black bears, fireflies and pigs. These were the products of creativity and innovations, along with over a month of teamwork by nine volunteers led by Zhou Xiu-qin. Although it was not perfect, the experiences gained from the experiments and failures were most valuable.

製作步驟

材料：圓形塑膠籃、PE泡棉、束帶

1 豬的軀體架構由數個圓形塑膠籃以束帶固定。

2 利用回收PE泡棉柔軟的特性作肌肉，修飾外觀線條。

3 以紙管當腳，穿到塑膠籃裏，用束帶固定。

4 上了紙漿的豬有了皮膚，形體模樣也更加清晰。

Steps of Creation

Required materials: Round plastic baskets, spongy PE foam sheet, wire ties

1 The structural frame of the pig model was built by assembling a few round plastic baskets which are firmly secured by wire ties.

2 Before wrapping up with spongy PE foam sheet to form the body. The characteristics of spongy foam sheet resembles the flesh texture and also contour of the animal.

3 With legs made of paper tubes which were inserted into the plastic baskets and firmly secured by wire ties.

4 After applying paper pulp to form the skin, the bodily feature of the pig model is now more distinctive.

1	2
3	4

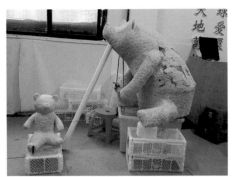
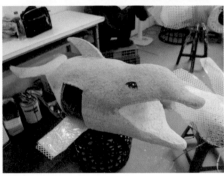
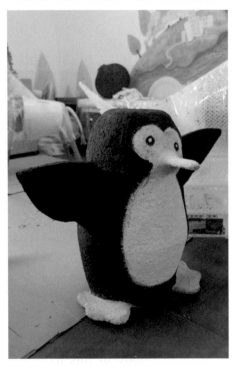

5　　　北極熊親子四肢和胸腹以芭樂套袋填充，為了避免大北極熊頭部變形，以兩條繩子牽引支撐。

6　　　上好紙漿的北極熊頭部很重，設法以管子撐住下巴，防止坍塌。北極熊身上有些不上紙漿的部位，是刻意裸露，意喻北極熊的棲地遭到破壞。

7　　　海豚肚子部位開口，是讓參觀者看到人類亂丟而被海豚誤食的塑膠垃圾。

8　　　企鵝寶寶是利用圓形和方形塑膠籃做出身體，內部以芭樂套袋填充，增加重量，穩定重心。外表上紙漿，靜置乾燥後上色，一隻可愛的小企鵝就完成了。

5　　　The limbs and abdomen of a polar bear model were filled with foam PE food packaging nets, while two pieces of strings were towed the head support and also avoid the polar bear's head deformation.

6　　　As the head of the polar bear model is very heavy after applying paper pulp, a pole was added to support its chin preventing it from collapsing. Part of the body remained bare to highlight the effect of habitat destruction to the animal.

7　　　An aesthetically pleasing dolphin model with paper pulp exterior. An opening at the abdomen was again left open intentionally for visitors to see the plastic trash that were mistakenly consumed as food by the dolphin.

8　　　The body of this baby penguin model was made of round and square plastic baskets filled with foam PE food packaging nets to increase its weight for stability. After covering the exterior with paper pulp, it was left to dry before painting it up to complete the model.

5	6
7	8

紙海龜

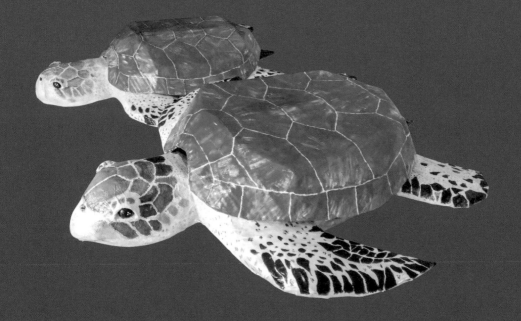

Sea
Turtle

紙海龜

創意發想／邱碧霞

　　二〇一九年參與浴佛節浴佛臺「保護海洋 尊重生命」的海龜與鯨豚製作。

　　事關環保教育，新聞報導中海龜誤食塑膠袋的畫面也時有所聞，感於減塑行動人人有責，因此透過作品呈現，引發人人有感而化為行動，在生活中落實環保減塑。

　　製作材料主要是來自回收紙箱，紙類回收再利用同樣是環保行動之一。

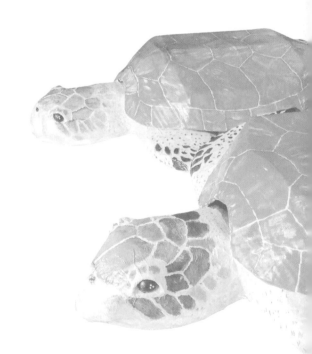

Sea Turtle

Idea Creator/Chiu Pi-hsia

At the 2019 Buddha Day Ceremony which was themed "Protecting the ocean, Respecting lives", the venue was decorated with craft models of sea turtles and cetacean.

As part of the environmental protection education, we often read on the news that sea turtle ate plastic bags which they have mistaken as food; thus, the objective of these artworks is to kindle sentiments in people, reminding them to be mindful on plastic responsibility and adopting towards an eco lifestyle.

The required material is from recycled carton boxes, which aligns with one of the main sustainability goals, that is the "Reuse" initiative.

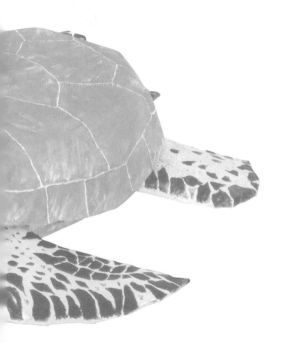

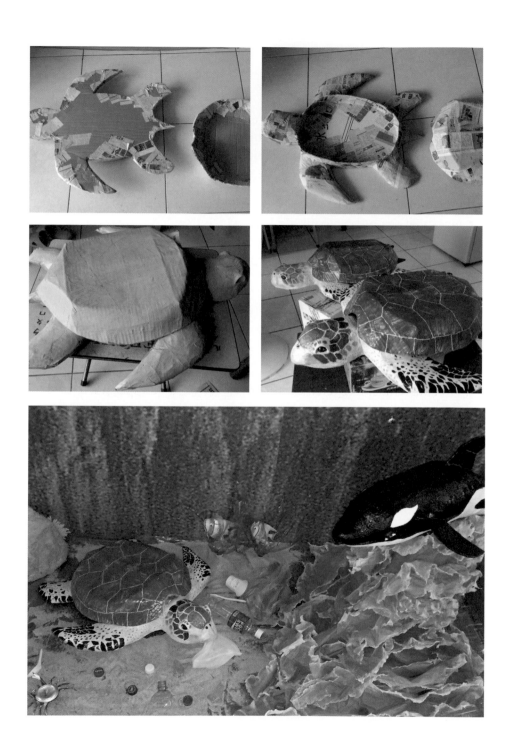

製作步驟

材料：回收紙箱、報紙

1 在硬紙箱上畫出背殼與身體四肢模型，裁剪後以膠布固定住。

2 以報紙做成長條狀及團狀，作為四肢、尾巴與頭部，呈現立體效果。

3 全部塑形完成後，將撕成條狀的報紙黏貼三層，外層塗以白色壓克力顏料。

4 依真實海龜外觀著色。

5 完成品。

Steps of Creation

Required materials: Recycled carton boxes, recycled newspapers

1 Draw the outline of the sea turtle's shell and its limps as well on carton box; cut out and join them together with adhesive tape.

2 Roll the newspaper into strips and lumps to make the turtle's limbs, tail, and head which will give it a stereoscopic effect.

3 After the whole shaping is completed, paste three layers of newspaper strips over it and apply white acrylic paint on it.

4 Lastly, paint the final layer of the model according to the actual colours of the sea turtles.

5 Artwork is completed.

1	2
3	4
5	

廢鐵小小兵

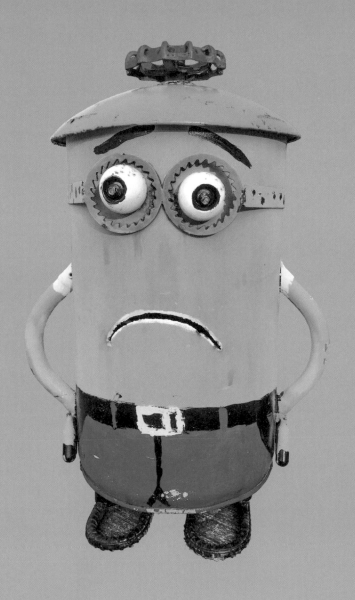

Iron
Minion

廢鐵小小兵

創意發想／鄭炳和

原開設機械廠，後來轉型做資源回收。二〇〇六年環保局希望資源回收場形象改造，我便做了兩件作品擺在回收場門口，有學校老師看到，很驚訝地說：「這是藝術品啊！」

資源回收場總是給人髒亂的感覺，我決定利用藝術創作來啟發大家對資源回收場不同的看法。陸陸續續以回收的金屬為素材，創作超過三百件作品，其中許多作品以逗趣、吸引小朋友為主，如天線寶寶、泰迪熊、小小兵等，成為老師帶小朋友來學習環保教育及資源分類的好動機。

將不同形狀的廢鐵，轉化成栩栩如生的作品，創作時，隨性結合當下時空背景，二〇二〇年的最新作品「小小兵戴口罩」因應而生。

以回收的冷媒桶、滅火器、鐵桶，焊接組合後上色，打造了一系列逗趣的小小兵家族。希望透過色彩繽紛的小小兵，讓大小朋友了解資源回收再利用的理念，一起為愛護地球盡一分心力。

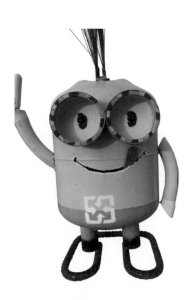

Iron Minion

Idea Creator / Zheng Bing-he

Originated as a machinery factory, it was subsequently transformed into a recycling centre. In 2006, the Environmental Protection Bureau wanted to change the image of recycling centres, which triggered my creation of the two minion models displayed at the Centre's entrance. By chance, it happened to attract the attention of a school teacher whom with much astonishment, felt it was a work of art.

Recycling centre often appears to be a dirty and a chaotic place, so I decided to use art sculpture to change such views. Sculping one after another, more than 300 pieces of artwork were created from salvaged metals, and many of these are crafted to attract children's attention. Of which, are Teletubbies, Teddy Bears, Minions and many others, which motivate teachers to bring their students to the centre for environmental protection education and sorting of recyclables.

Randomly drawing inspirations from observing the surrounding setup, these salvaged metals of different forms are turned them into vivid art sculptures. That was how the latest artwork in 2020 - "Minion in Mask," was created.

A series of adorable minion families was created by welding salvaged refrigerant tanks, fire extinguishers, and metal barrels, hoping that through the fun and colorful minions, both adults and children will appreciate and understand the concept of recycling and reusing resources, eventually coming together to contribute in protecting our planet.

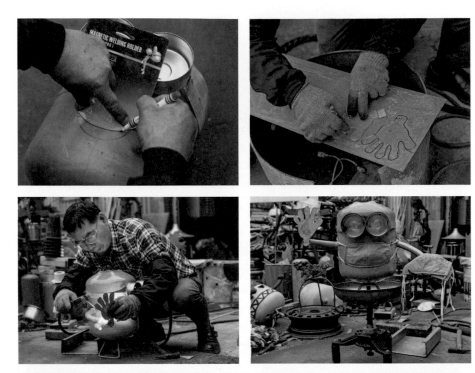

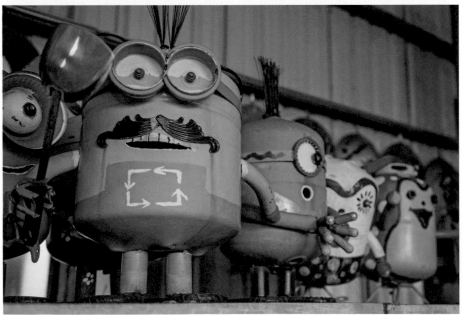

製作步驟

材料：冷媒桶、回收鐵皮、水電彎管、口罩

工具：電離子切割機

1~2　　取冷媒桶，以回收的鐵皮焊接眼睛，利用廢紙描畫嘴巴和手掌。

3　　焊接手臂。

4　　因應疫情緊迫，小小兵戴上口罩。

5　　小小兵排排站。

Steps of Creation

Required materials: Refrigerant tank, scrap metal sheet, pipe bender, mask

Required tools: Ion cutting machine

1~2　　Using a refrigerant tank, weld the eyes of the minion on it from scrap metal sheet. Outline its mouth and palms on metal sheet with waste paper cardboard, cut them out.

3　　And weld onto the tank along with it arms that are made from pipe bender. The process is now completed.

4　　In response to the pandemic, a mask was worn.

5　　On the Minion.

1	2
3	4
5	

分盆栽盆

象

鴨甲

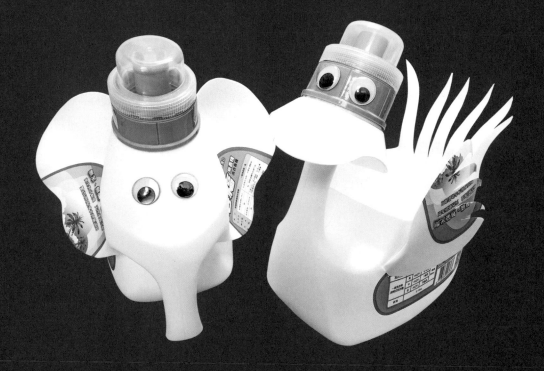

Elephant /
Duck
Design Pot

象鴨盆栽盒

創意發想／曾雅玲

　　洗衣瓶做成的象鴨盆栽盒，起因在我們的手機通訊軟體「365大地園丁群組」中，有一位馬來西亞志工貼出圖片，引得群組內鼓起學習之聲。

　　大家都想學，如此對環境有助益的因緣必然要把握，便啟發我試做的動力。也因此，臺灣象鴨產生了！

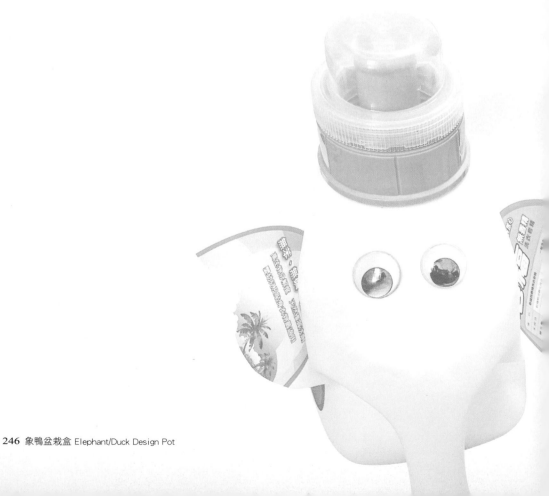

Elephant/Duck Design Pot

Idea Creator / Yalin Tseng

The creation of these items was inspired by a volunteer from Malaysia who shared a photo of it in the "The line group of 365 Earth Guardian", an online chat group which triggered appeals from fellow chat group members on their desire to learn the craft.

Motivated by fellow group members' keen interest to learn and the eco value in it, led to the materialisation of this creation.

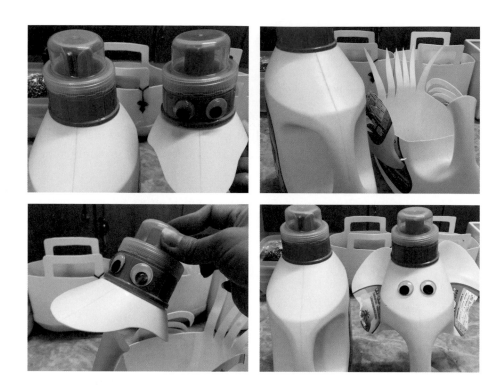

製作步驟

材料：HDPE洗衣精瓶、塑膠眼睛

1~2　　分離瓶身上下部，分別剪出鴨頭和鴨身。

3　　　在鴨頭貼上眼睛，以尖嘴鉗壓住鴨身塞入鴨頭，完成。

4　　　大象做法同上。

Steps of Creation

Required Materials: HDPE laundry detergent bottle, wiggle eyes

1~2　　Cut the top opening portion from the bottle handle. Using the top part, trim out the shape of a duck beak and head.

3　　　Glue a pair of wiggle eyes on the head. Use the bottom of the bottle, trim out the shape of the duck body. Insert and fix the head of the duck into the handle of the bottle. Duck design pot artwork is completed.

4　　　Crafting the elephant design pot is similar as per above steps except the bottle handle is spilt to be part of the top portion to become the elephant trunk, see above picture.

1	2
3	4

朔月塑膠袋代花

Flower

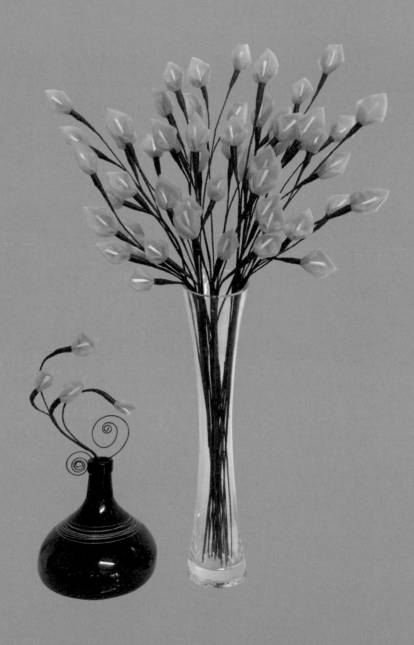

塑膠袋花

創意發想／曾雅玲

　　環保志工受證時所佩戴的環保胸花，促動我發想，把在上班途中發現被丟棄在路旁的雨衣，撿回來製成花朵，希望藉由創意吸引更多的人關心——日常生活中不經意丟棄的垃圾，均能轉化成寶。當大家都願意多看一眼，哪怕只是幾秒鐘，「它」就是一個好的說法工具，進而達到愛惜物命、減少丟棄的作為。

　　我在製作這件作品時，淨（靜）定、念茲在茲十分療癒，很享受這攝心三昧的過程。期待大家能和我有一樣的經驗，為環境一起加油！

Flower

Idea Creator / Yalin Tseng

The eco-friendly corsage as worn by Environmental Protection volunteers during their certification ceremony inspired the thoughts to upcycle an abandoned raincoat found on the way to work into a flower, with the hope of raising greater public awareness through such creativity. Garbage that are inadvertently created in daily living can be converted into treasurable resources if we are willing to give it one more thought before trashing them. Take for example these upcycled flowers, even if it garners only a few seconds of attention, it has become a good tool through reminding others to reduce wastages and cherish what they have.

In the process of making these artworks, when all thoughts are gathered onto each moment, the feeling of serenity is a pleasurable experience indeed. Hope everyone can pitch in too on this meaningful effort for our environment and at the same time experience the same joy while going through it.

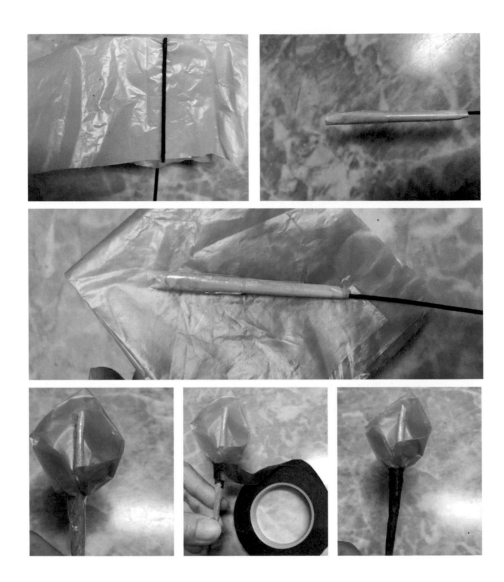

製作步驟

材料：回收塑膠袋、回收紫色雨衣、鐵絲、紙膠帶、膠帶

1~2　　取黃色塑膠袋，去掉提環和底部，剪出八公分寬長條，彎曲鐵絲勾住捲緊，膠帶固定。

3~4　　取十六公分寬紫色雨衣長條，折成八公分正方形，在對角線放上鐵絲，左右兩邊向裏捲，以膠帶固定。

5~6　　花朵底部繞上紙膠帶，完成。

Steps of Creation

Required materials: Recycled plastic bags, recycled purple raincoat, steel wire, paper tape, adhesive tape

1~2　　Using a yellow colored plastic bag, cut off its handle and bottom portion. Next cut out an 8cm wide strip and use it to wrap the steel wire tightly. After which, secure it with adhesive tape.

3~4　　Cut out a 16cm wide strip from the purple raincoat, fold into an 8cm square. Place the above steel wire diagonally across the raincoat, fold the lower portion inward from both sides and secured with adhesive tape.

5~6　　Wrap the bottom of the flower with paper tape and artwork is completed.

1	2	
	3	
4	5	6

雨傘　布背包

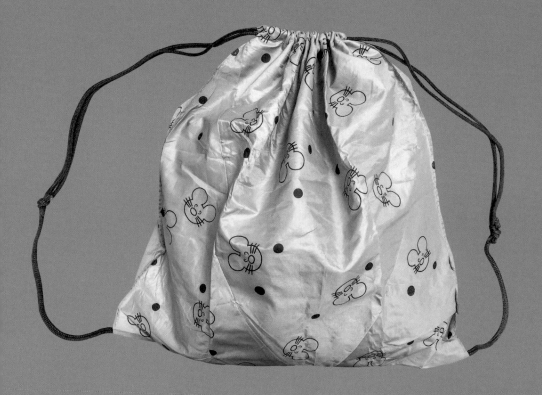

Umbrella
Fabric
Bag

雨傘布背包

創意發想／曾雅玲

在「365大地園丁群組」，有志工感嘆：能賣的資源有人撿，而廢雨傘被丟棄在路旁，人來人往無人過問！

有志工好意將它們撿回環保站，便又引發我試做動力。製成環保背袋，防水超輕攜帶方便。環保心、針線情，看似無法再使用的壞掉雨傘，經過巧手後有了嶄新生命。

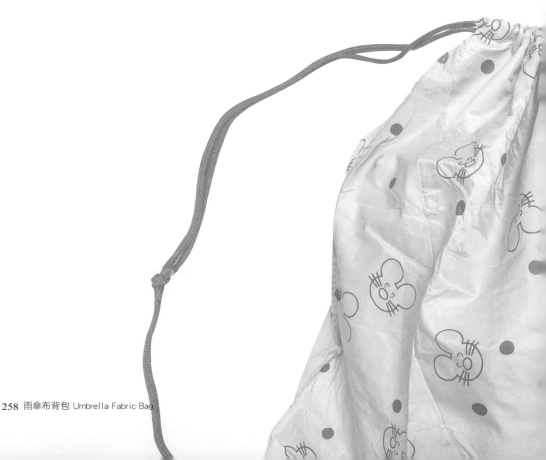

Umbrella Fabric Bag

Idea Creator/ Yalin Tseng

Volunteers of the "The line group of 365 Earth Guardian" group was sad to learn that nobody took notice of those broken umbrellas that were discarded at roadsides whereas other items that has resale value were widely collected.

Some volunteers would collect and send discarded umbrellas back to the recycling station which were eventually converted into drawstring bags. Not only is it waterproof, it is lightweight and convenient to carry. With a willing heart to protect the environment, even an unwanted broken umbrella can be transformed and given a new lease of life through skillful means.

製作步驟

材料：壞掉雨傘、回收腰帶繩

1 拆下雨傘布，分成三等分，上下往內折，將腰帶繩垂直放在中線。

2~4 雨傘布對折後，手縫袋子兩側，袋口頂端反折兩公分，縫到距離頂端一點五公分處打結。

5~6 袋口頂端反折兩公分，穿入腰帶繩手縫一圈，完成。

Steps of Creation

Required materials: Broken umbrella, recycled drawstring waistband

1 Remove the umbrella fabric and divide into 3 equal sections. Both outer sections to be folded towards the center, then place the drawstring in the middle where it is on top of the folded sections.

2~4 Bring both open-ends of the fabric together symmetrical then hand sew both sides tight but allow both top open-ends to be folded inward leaving a 1.5cm gap for the drawstring.

5~6 Fold and sew a 2cm gap of the bag opening for inserting a loop of the drawstrings within.

袋子

利樂包

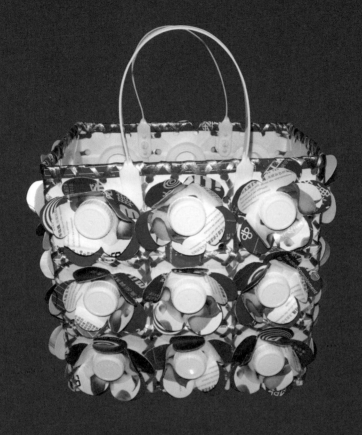

Tetra
Pak Bag

利樂包袋子

創意發想／曾雅玲

在炎熱的夏日裏，喝完鮮奶後，瓶子若未即時清洗、存放個兩三天，腐敗的味道真令人不敢恭維。送到環保站分類時，總孳生許多小生物，累得環保菩薩們須仔細清洗再分類。

利樂包，俗稱鋁箔包，不但防水又不會割傷人，其中的鋁箔可以抗紫外線輻射，是製作帽子很好的材料。

我在試做帽子時僅使用利樂包瓶身，剩餘的瓶底捨不得丟棄放在一旁，思索利樂包材質耐水的特性，發想試做成袋子看看。

試做結果出奇地好用，耐水又耐重，且所有材料均來自環保再利用，不浪費資源，因此法喜不已！

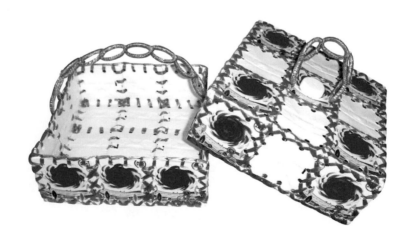

Tetra Pak Bag

Idea Creator / Yalin Tseng

When milk bottles are not washed immediately after use, after a few days, it gives out a stench nasty enough to deter anyone from coming close. Not only that, when it reaches the recycling facility, maggots can even be found to have been bred in it, which burdens the volunteer's work of segregation as they would need to cleanse them before it can be sorted accordingly.

Tetra Pak, which is commonly known as aluminum foil package, is not only waterproof but also blunt enough that it does not cut nor injure by accident. The aluminum foil content in it can also resist ultraviolet radiation and is a good material for making hats.

While making hats out of Tetra Pak bottles, the remaining unused bottom portion sparked the thought of upcycling them into bags, with consideration of their water-resistant characteristics.

The end results were amazing as it turns out, not only being water resistant, they have good load bearing qualities as well. Best of all, it is crafted entirely from reusable and recycled materials, not wasting available resources in its process of materialisation. Such is truly worth rejoicing in!

 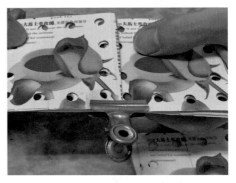

製作步驟

材料：回收利樂包

工具：打洞器、剪刀、筆、尺、夾子、髮夾

1　　　剪下利樂包四方形底，以之當模版，描繪在有圖案的利樂包紙上，裁剪下來。

2　　　將一層圖案加上一層底，以橡皮筋綁在一起，畫出打孔記號。

3　　　打孔。

4　　　每組裁片重疊零點五公分，以鐵夾固定。

Steps of Creation

Required materials: Recycled tetra pak packaging

Required tools: Hole puncher, scissors, pen, ruler, metallic binder clip, hairpin

1　　　Cut out the square bottom portion of the Tetra Pak and use it as a template for drawing outline on the printed surface of the Tetra Pak paper layer. Cut it out after doing so.

2　　　Stack up a pile of Tetra Pak bottom pieces and bind them with rubber band. Draw hole punch marks.

3　　　Punch holes accordingly.

4　　　Overlap two layers together, with the top layer overlapping the bottom by 0.5cm. Firm the overlapping layers with binder clip.

1	2
3	4

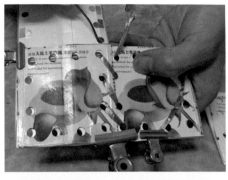 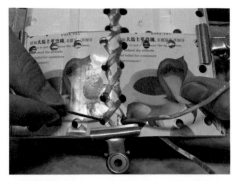

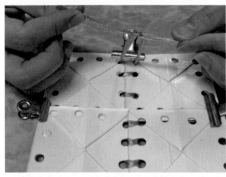

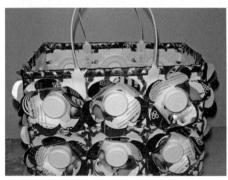

5　　　　以髮夾穿塑膠繩，斜線往下穿。

6　　　　一邊增加裁片，至所需長度後反向穿線形成交叉。

7　　　　回到起始點在背面打雙結，剪掉餘線。

8　　　　完成前後左右及底部後組合，

9　　　　銜接邊呈九十度角縫合，加上提帶和裝飾，完成。

5　　　　Thread a piece of raffia string into a hairpin (as needle).

6　　　　Guide it into the punched holes, and thread the hairpin into the subsequent holes while adding on more stacks of the Tetra Pak piles until reaching the desired dimension.

7　　　　Reversed the threading forming a cross thread. Return to the starting point and double knot on the back and cut off the left.

8　　　　Repeat the same process to form all sides of the bag (front, back, left, right and bottom)

9　　　　Thread them together at 90-degree angles, Finally, complete it with the addition of strap and decorations.

5	6
7	8
9	

作品觀摩

小智研發致力於回收材料研發科技，將回收瓶蓋料進行再製，轉變成為具防水且高實用性的寶特磚。

MINIWIZ's mission- Accelerate world's transition to zero-waste through material innovation, technology and design. TRASHPRESSO turning the bottle caps(rPP) into tile, it gives new value to trash within 5 minutes to process on site.

Artwork showcase

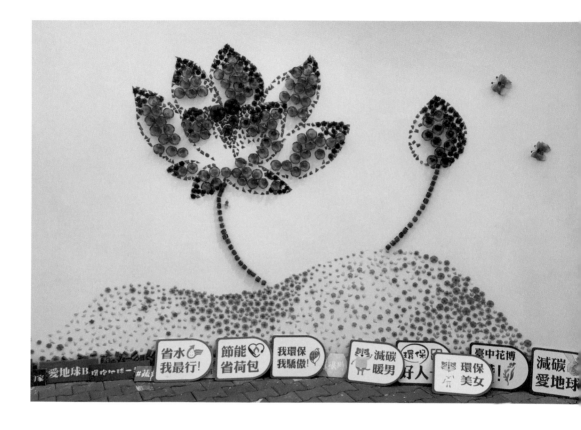

蓮花寶特瓶打卡牆，二○一八年臺中花博展出。
（創作者：曾雅玲）

Lotus flower decorative wall made from PET bottles at 2018 Taichung Floral Exposition. (Idea Creator: Ya-Lin Tseng)

飛上天空，
您怎麼看地球？

蝴蝶展翅寶特瓶打卡牆，慈濟環保三十臺中靜思堂展布。

Exhibiting a pair of butterfly wings spreading on a PET deco wall at the
Taichung Jing Si Hall's Tzu Chi Eco Mission 30th anniversary showcase.

吸管櫻花樹，二〇一八年屏東燈會。

A straw-made Sakura tree at 2018 Pingtung Lantern Festival.

竹筍塑膠湯匙花燈，二〇一八年屏東燈會。

Lotus flower lightings created from bamboo shoot plastic spoons, exhibited at 2018 Pingtung Lantern Festival.

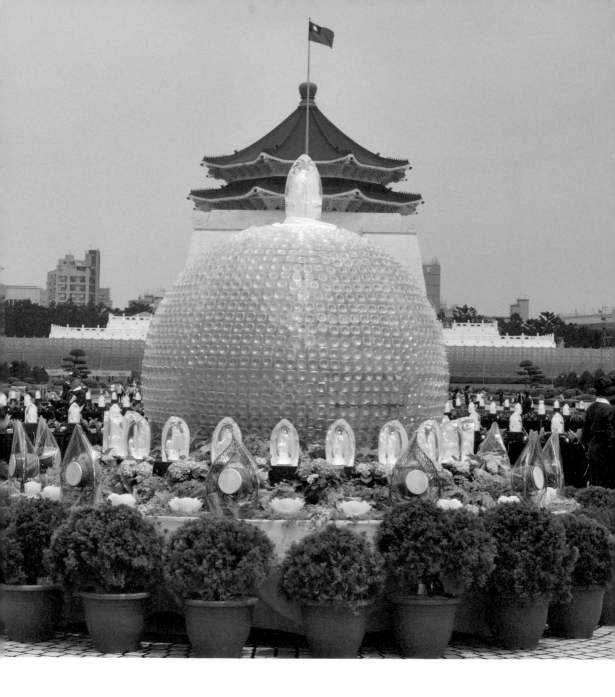

寶特瓶地球，二〇一九年臺北中正紀念堂浴佛。

Globe created with PET bottles at 2019 Taipei Chiang Kai-shek Memorial Hall's Buddha Day Ceremony.

靜思語轉法輪，PVC塑膠。
（創作者：三重羅美珠團隊）
Jing Si Aphorism wheel created from PVC pla
(Idea Creator: Sanchong area Mei-zhu Luo exhibition team)

竹子菩提樹，二〇一八年臺中花博展出。

Bamboo-made Bodhi Tree at 2018 Taichung Floral Exposition.

石蓮花、木蘭花，回收洗衣精瓶，二〇一八年臺中花博展出。
（創作者：曾雅玲）

A Graptopetalum paraguayense and Magnolia created from recycled
plastic detergent bottle, exhibited at 2018 Taichung Flora Exposition. (Idea
Creator: Ya-Lin Tseng)

蝴蝶效應時鐘，寶特瓶裁片，二〇一六年高雄靜思堂布展迄今。
（創作者：曾雅玲）

Butterfly Effect clock created from pieces of PET bottle, exhibited at
Kaohsiung Jing Si Hall since 2016. (Idea Creator: Ya-Lin Tseng)

鼠你最棒，PVC塑膠。（創作者：鄭明宗）

Models of mouse created from PVC plastic. (Idea Creator: Ming-Tsung Cheng)

藍鯨、白海豚，寶特瓶蓋拼圖，慈濟環保三十臺中靜思堂展布。

（創作者：中區王建中、林淑嬌、吳麗華布展團隊）

A collage of blue whales and white dolphins created from PET bottle caps,
exhibited at Taichung Jing Si Hall's Tzu Chi Eco Mission 30th anniversary
showcase. (Idea Creator: Central zone Jian-Zhong Wang、Shu-Jiao Lin、
Li-Hua Wu exhibition team)

讓「什麼都不做」成為良藥

◎吟詩賦

五月，荷花遇上梅雨，雖然被打臉得有些氣餒，但畢竟是正當季，仍是露出魅力容顏。

五月，通常是慈濟世界極為熱鬧的時候，「浴佛節、母親節、全球慈濟日」三節合一的日子，全球大型浴佛活動，感念佛恩、親恩、眾生恩。

但這一切，今年由於新冠肺炎疫情，全都變調了。沒有大型活動，小型的祈禱祝福會人人戴著口罩上場，如果把時空拉遠，還以為是當年流行趨勢；其實在口罩下，是全世界性命交關的驚恐。

防疫期間，大家減少外出避免群聚感染；待在家裏，看電視劇的頻率倒是增加了，無意間看到這齣據說是真人實事為底本的《什麼都不做的出租先生》。

主角在太太的支持下從職場退下，委託人只要付車資和同行間的飲食費用，就可租用主角作為傾聽、陪伴、湊人頭軋一腳的角色，租用期間，主角什麼都不做、回答問題只限最基本的對答。

花錢請人來「什麼都不做」，如此不對等的「利益交換」，當真會有人使用嗎？結果出租先生的「業務」異常熱絡，竟然需要排行程去「什麼都不做」。

有人請他用「意念」提醒自己辦理重要的事、孕婦請他祝福自己順產、不好意思邀請親友的老年情侶請他來見證婚禮、命不久矣的獨居老人請他一起選購告別式用品等事宜……種種意想不到的情況，出

The healing remedy of "Doing Nothing"

◎Yín Shī Fù

During the monsoon season in May, despite the heavy rainfall, the lotuses in ponds still thrives and blooms.

May is also a significant month of the year for Tzu Chi Foundation, as this is the month where the foundation held its Buddha Day ceremony in conjunction with Buddha Day, Mother's Day and Tzu Chi Day across the world, as a tribute to the grace of The Buddha, as well as those of our parents and all beings.

However, things did not go as usual this year with the Covid-19's global impact, where the yearly large-scale ceremony was scaled down along with an uncommon sight of masked participants. If this was a look back in time from the future, the masked sight might be easily mistaken as a viral trend in this time of history.

During this period of pandemic, more time was spent at home, and as the frequency of watching TV shows increases, this show by the name of 《Lease Man Service》 which was inspired by true life events, was accidentally stumbled upon.

The story revolved around the lead character who resigned from his full-time career to become an ad-hoc companion for hire with the support of his wife. The person who hires his services is only required to pay for his transport and meal expenses during the period of interaction. The lead character is basically hired for his presence and to do nothing at all with very limited responses while interacting.

Would there really be anyone who would engage in such uneconomical idea of hiring someone to literally do nothing? Unexpectedly, the man-for-lease service became very popular, to the extent that his schedules are very full and require advance bookings. Of those whom hired his services, are people whom wanted him to remind them of their important tasks to do, expecting mothers wanting him to send his well wishes for a smooth

租先生因為「什麼都不做」，而讓什麼心防都鬆解了，最後往往是委託人自己找到了生命出口，自行得出解決之道。

什麼都不做的出租先生除了有太太，還有一個年幼的孩子，身為一家之主、經濟來源，真的能一直「什麼都不做」嗎？其中一集是岳父岳母突然來訪，發現女婿辭去工作而且「什麼都不做」，岳父大發雷霆，斥責女婿不負責任，不能給女兒和外孫幸福。

劇情中最後當然是化解了衝突，讓主角繼續「什麼都不做」。「什麼都不做」，在華人世界聽來多麼違和！看到地上有紙屑，如果不撿，豈不是愈來愈髒亂？看到馬路上孩子有危險，如果不上前拉一把，豈不是有性命之憂、良心也過不去？

但是可曾想過，如果沒有人亂丟垃圾，就不需要特別有人去撿；如果人人都遵守交通規則，大人顧好小孩、開車的人注意行路安全，就不需要擔心危險。

慈濟推動環保三十年，期間發起「清淨在源頭」的口號和行動。人人不做無謂消耗，不要製造那麼多垃圾，生活的環境肯定清淨清新；必須的消耗做好「回收分類」，讓資源循環再利用，就能少挖一些礦、少一些製造過程中產生的汙染，讓地球的負擔少一點，讓大地的生命更長久。

希臘醫學之父希波克拉底（Hippocrates）的名言：「讓食物變成你的藥，讓藥變成你的食物。」改寫這句名言，期待讓「什麼都不做」成為環境保護的良藥，除了愛，人人對地球什麼都不要做。

中國道家提倡「無為」，真正的無為才能「無不為」；佛家的「真空妙有」，捨棄了執著，才能擁有滿足和幸福。本書「化廢為寶」裝置藝術作品，正是以愛惜的心，讓一度廢棄的物品，成為各有

labour, elderly lovers hiring his services to witness their wedding ceremony (as they were too embarrassed to invite their families and friends) and socially isolated elderlies whom are nearing the end of life engaging him for his companionship while going through the details of their funeral arrangements.

As the main bread winner of the family, this lead character has a wife and a young child to support, so can he really sustain by this lease service job? In one of the episodes, his in-laws visited them out of the blue and learnt of his career switch which angered the father-in-law whom gave him a dressing down for compromising the stability of the family's livelihood though subsequently they too consent to his new-found occupation.

Such concepts of impassivity would definitely not resonate well especially in Chinese societies. However, imagine a society where people turn a blind eye to social responsibilities, unsympathetically ignoring the need for a helping hand even in life and death situations like saving a child from an impending traffic accident, or even everyday situations like conveniently picking up litter from the floor.

On the other hand, if no one litters, there would be no dirty streets. If everyone abides closely to traffic regulations and parents attending to their children responsibly with drivers paying attention to road safety, there will be no concerns on one's safety while out on the roads.

Tzu Chi's environmental protection mission is at its 30th year mark and during which, "Sustainability at source" was one of the initiatives that was launched and strongly promoted. As the name speaks for itself, this environmental protection concept focuses on avoiding unnecessary consumption of resources and reducing the volume of rubbish created which will naturally lead to a cleaner living environment. As for those inevitable trash, we recycle them right so that these resources can be reused again which helps to reduce the mining of natural resources and pollutions from manufacturing processes so as to lessen the load on our planet Earth thus extending its lifespan.

The famous quote from the renowned father of medicine in Greece - Hippocrates "Let food be thy medicine, and let medicine be thy food", let

表情的新創作。

在地球上散步，身心都沒負擔，需要人人都來「什麼都不做」，只做「化廢為寶」，煥發「妙有」、知足的光采，使得後代子子孫孫繼續踏著亮麗的足跡而行，安心與地球共生息。

us draw inspiration from it to be "inactive" which will become the remedy for environmental problems if we embrace our planet with love and mindfulness of doing no harm to it.

Just like Taoism which promotes harmony to cease conflicts and reach true abstention, Buddhism's concept of subtle tangibility within the state of emptiness advocates on giving up attachments to gain contentment and blissfulness. Turning trash into treasures through the work of art is the representation of this book, which is also an expression of cherishing resources from the heart, thus giving life to these renewed creations.

In order to feel no guilt or burden as we stroll on this planet, everyone needs to step up and start "Doing Nothing" and yet just keep doing only one thing, that is the act of turning trash to treasure, thus reflecting the subtlety in tangibility, leaving the radiance of contentment from this generation to the next as they continue to step foot on the paved and treaded path of environmental conservation. With that, they will thrive and strive to live in harmony with our planet Earth from the legacy we leave behind.

國家圖書館出版品預行編目（CIP）資料

環保創藝 化廢為寶／曾雅玲等作；陳玟君主編
初版 — 臺北市：慈濟傳播人文志業基金會，2020.09
288面；17×23公分 — 中英對照
ISBN 978-986-5726-93-5（平裝）
1.環境保護 2.廢棄物利用 3.藝術 4.作品集
902.33 109013485

環保創藝 化廢為寶 Creativity x Trash = Art

創 辦 人／釋證嚴
發 行 人／王端正
平面總監／王志宏

作 者／
曾雅玲（Yalin Tseng）、周秀琴（Zhou Xiu Qin）、陳哲霖（Chen Jer Lin）、陳建雄（Chen Jian Xiong）、陳寶娟（Chen Bao Juan）、邱碧霞（Chiu Pi Hsia）、鄭明宗（Cheng Ming Tsung）、鄭炳和（Zheng Bing He）

翻 譯／
李魁勉（Lee Kwei Mean）、張啟霞（Chong Chee Sia）、蔡惠萍（Chua Hwee Pheng）、蔡偉中（Chua Wee Chong）、劉木平（Lau Buck Peng）、任耀娟（Yam Yeow Kian）、蔡振國（Chua Chen Kok）、江儀雯（Kong Yee Mun）、江石獅（Jordan Kang）、張愛香（Teoh Ai Heong）、黃筱丹（Ng Xiao Dan）、林明達（Lim Ming Tat）、陳潤敏（Tan Jun Min）、余惠惠（Yu Huei Huei）、余元元（Yu Yen Yen）、黃兆偉（Huang Zhao Wei）、莊晉峰（Chong Kim Hong）、梁雪英（Leong Seak Ing）、王秀娟（Wong Siew Kuen）、陳詩筠（Tan Shi Yun）、謝忠明（Richard Shia）、謝佳君（Seah Jia Jun）、符史柏（Foo See Pock）、何秋鋒（Ho Siew Fong）、林麗珍（Lim Ley Chin）、黃德源（Ng Teck Guan）、辛建益（Roger Seen）、吳永壽（Goh Eng Siew）、盧小燕（Yanti Low）、符永裕（Foo Yong Jio）、林光耀（Lim Kuang Yaw）、王威勛（Ong Wee Heng）、羅碧修（Loh Peck Siew）、許振耀（Khor Chin Seng）、蔡祝平（Chye Chook Ping）、潘建銘（Phoon Kin Ming）、劉明光（Liw See Kew）、陳蘇姍（Susan Tan）、林學仁（Steve Lin）、陳敏理（Mindy Chen）

主 編／陳玟君 企畫編輯／邱淑絹
特約編輯／吟詩賦 執行編輯／涂慶鐘
美術指導／邱宇陞 美術設計／翁士婷
校對志工／高怡蘋

出 版 者／慈濟傳播人文志業基金會
地 址／112019臺北市北投區立德路2號
編輯部電話／02-28989000分機2065
客服專線／02-28989991 傳真專線／02-28989993
劃撥帳號／19924552 戶名／經典雜誌
製版印刷／新豪華製版印刷股份有限公司
經 銷 商／聯合發行股份有限公司
 231028新北市新店區寶橋路235巷6弄6號2樓
電 話／02-29178022
出版日期／2020年9月初版一刷
 2022年7月初版二刷
 2022年8月初版三刷
定 價／新臺幣320元

內封面為 100% 環保再生紙
書衣和內頁用紙符合森林管理委員會 FSC 認證